Dirty Theory:
Troubling Architecture

Hélène Frichot

Contents

Introduction
Dirty Theory:
Troubling Architecture

There is nothing very respectable about dirty theory.
It seeks out approaches and plots trajectories from
a position close to the ground. We must move past
our disgust, to work with the dirt: This is an impera-
tive for coping with our dusty, dirty, defiled world. To
think with it, not against it. Dirt never emerges from
nowhere, *ex nihilo*, but from beneath your feet, from
under your fingernails, from encounters and relations
and from the accumulated odds and sods that
compose any mode of life. A life, where it is not stulti-
fied as *nature morte*, is inevitably dirty, messy, buffeted
by contingencies. Theories, ways of actively think-
ing-with, can be derived from all kinds of sources and
situations. The dirty theorist is usually something of
an avid collector, accumulating not just the regular set
readers – written by the usual theoretical suspects –
but pamphlets, brochures, maps and postcards,
snatches of conversation and grabs of social media
feed, accepting all the while that distinctions between

low and high culture are easily undone. (An old lesson we keep forgetting, caught up as we are in a will to purification.) What was once sacred and revered in the next moment may well be expelled as abject, judged to be without sense, useless. The dirty theorist follows the materials, tracks the soiled effluent, observing from where it came and the direction that it appears to be taking. She is unafraid of selecting at will from the sedimented archive of thinking.

Dirty theory messes with mixed disciplines. Showing up in ethnography, in geography, in philosophy, it can just as well find a home in architecture, design and the creative arts. Dirt and art have an existing long-term relationship, whether rendered as negative sculptures extracted from the earth, or maintenance manifestos or soil re-valued as currency. Dirt and architecture – beyond the uptight habits of the archetypal heroic architect's will to purification and hygiene – admits sly allegiances here and there. David Adjaye's Dirty House dabbles in dirt, but better still, Katherine Shonfield's transient installations dig deeper and Jennifer Bloomer's dirty ditties and dirty drawings conspire to imagine architecture otherwise. Dirty theory helps architecture think about the ordinary gestures of care, repair and maintenance that can form part of its mandate. Most powerfully, following the dirt can be a creative movement, a profound relationship with our local environment-worlds.

Dirty theory is wary of the strictures of disciplination, preferring instead indisciplination, a wayward approach to problems. It's scattergun, if not scatological. Dirty theory appropriates and critically, knowingly, misappropriates, because ideas do not belong to singular authors, the dirty theorist avers. Dirty theory, the dirty theorist and the theory slut herself are not very respectable, rational or reasonable figures. The preferred approach here is one of a "groping experimentation" (Deleuze & Guattari 1994, 41), to quote that still disreputable pair, Gilles Deleuze and Félix Guattari. Groping the world, prehending it, trying not to grasp it too hard. To be respectable means to have accepted and internalised the status quo, where everything and everyone is agreeable and none are prepared to rock the boat. To rock the boat would be to place oneself at risk of being thrown overboard, only to discover that the mythical island of reason has disappeared into the mists. To be rational assumes that reason has been determined in advance, and that everything can be organised in good measure. To be reasonable, well, it means you are prepared to get along and are certainly not a woman who makes a fuss. The reason that supports the reasonable ("be reasonable now!") assumes that each thing has its proper, measured and assigned, place. Once a title on the lands belonging to reason has been secured, and "a solid foundation to build upon" (Kant 1979, 180) has been

established, why should we not be contented? Why venture further? Beyond the island of truth, as Immanuel Kant has famously expounded, we only risk venturing further into the fogs of illusion. Yet islands, in this age of concatenating global climatic crises, rising sea levels, micro-plastics and pollutants, turn out to be not so secure after all. Island, land, dirt, all proffering opportunities for the cultivation of reason: There is more than a whiff of the colonial impulse in this territorialisation of dirt. Pure reason must be muddied. Dirty theory thus has additional labour in the political project of decolonisation, and even in the decolonisation of the otherwise too clean imaginary. Dirty theory demands that other voices be heard.

The dirt, the earth, is the required ground in which concepts can be planted and eventually bloom as flowers or weeds (either way). Dirty theory, you see, is neither good nor bad per se; like flowers or weeds it depends on the situation, the relations at hand, on what comes together to form a greater or a meaner composition. The dirt may not be sufficient for anything at all to grow. To territorialise, to deterritorialise, to reterritorialise – all such movements depend on the dirt rendered as the earth, *la terre*, beneath your feet, between your fingers, in your mouth as you utter a furious expletive. Without these movements-utterances, not much would be achieved, for good or for bad, and you are bound to get dirty either way.

It is the anthropologist Mary Douglas who famously offers the neatest definition of dirt: Dirt is matter out of place (Douglas 1966, 36). Matter located where it is judged not to belong. Judged as such by someone, or rather, judged by some societal context organised around societal norms and structures. Douglas explains that this simple formula directs us toward order and then the contravention of ordered relations. Dirt is that which crosses boundaries, challenges decorum, contravenes norms. The low, the reduced, the underfoot, the despised, the rejected, the expelled are at the same moment the accumulated ground upon which the powerful steady themselves in order to reach rarefied heights. Dirt carries material and conceptual weight, it is part of the stuff of all manner of corporeal relation, and it is also symbolic. Dirt registers the conjunction of the material semiotic. It invokes unholy mixtures of concepts and materials, of words and what matters. Jennifer Bloomer puts it plainly: "The world and the language are all tangled around each other" (1993, 87). The tangle should be read as a growing vine, a process of entanglement, as of that emerging from the mouth of the young woman in Botticelli's painting *Primavera* [Spring] (1478); either she is choking on, or else she is vomiting up, growing life.

If it is Douglas who represents dirt for the ethnographers, then it is the architectural thinker-doer Jennifer Bloomer who best represents dirt for the

architects. She represents it in such a way as to steal it from the grasp of the would-be phenomenologists, and those who would wax lyrical about dirt as an elevated outcome of weathering (Mostafavi & Leatherbarrow 1993), or celebrate the aesthetic effects of dust or seek a metaphysics of the imperfect and impure. Much like violence when violence exudes a curious fascination in its beholder, dirt is ever at risk of aestheticisation. Despite this risk, cannot a dirty theory enable creative possibilities beyond mere aestheticisation – creative possibilities that can make a critical difference where it matters? Bloomer, I believe, can help show the way.

With architecture, we are ever at risk of rendering dirt bucolic and rustic, of laying it out for our phenomenological enjoyment. Bloomer, who will play an important part in what follows, has darker tales to tell concerning dirt. She mixes water and blood, mixes words and matter, putting things purposively where they do not properly belong. An example: On introducing the beloved architectural motif of the poché, the secret that is supposed to properly reveal the deepest phenomenological desires of the architect, she shows instead the hole at the back of the wardrobe through which a young girl escapes from sexual abuse; the poché becomes the after-effect of a cigarette burn, the dirt that comes from the violence that is hidden behind the stern façades of what are supposed to be proper family men (1993, 178-179). Sobering scenes

for a dirty theorist. In this sleight of hand Bloomer deploys feminist resistance in response to the accepted definition of poché, which instead gives way to matter in the wrong place. Trailing behind Bloomer, suddenly a standard definition breaks into narrative and is off and away. This is no Bachelardian reverie in her discourse, no, it is nothing so saccharine as that. The phenomenological sacred is instead rendered profane and filthy. This is critique, what I would call material semiotic critique, an elegant slippage. The clean sheet turns out to be smudged.

Why get dirty? Why dirty theory now? Dirt is what gives relief to the mark drawn on the dusty ground with a stick to say: inside/outside, included/excluded. To mark, as Michel Serres explains, means to leave a footstep in the soil, and thus to claim, and reclaim, a territory (2011, 2). Dirty theory is a reminder that theories are good for nothing unless they are bound up with the muck of mundane relations on the ground, with the kind of environmental things that are increasingly at stake today, that were at stake yesterday, too, and that certainly will be at stake tomorrow. Make a mud map, find your way through the dirt. The temporalities of dirt take us all the way from property rights to a call for the commons and a return to practices of communing, getting dirty together. These are what Maria Puig de la Bellacasa calls "soil times" (2017). Dirt is in the body, the home, the environment (Cox et al. 2011)

and in all that we share and divide. At its best, dirty theory could participate in the imagining of new modes of getting messy together, accepting what Donna Haraway calls our messmates: our more-than-human relations. Dirt demands that we listen to the environment-worlds in the midst of which we lose and find ourselves, becoming and unbecoming. Dirty theory is concerned with discovering new ways of getting along with each other that challenge fixed categories, that track a diagonal and even a zig-zag course across taxonomic charts to invent new kinds of territories. *La terre* is what dirt might aspire to become, as long as the Earth is something that can be adequately, equitably shared.

There are thinkers of dirt, and they are diverse. I will attempt in the short chapters that follow to think-with them. There are practitioners of dirt, who understand the nutrient bases of the dirty work required, who can remind us of how some contact with the dirt can build up our immunological systems and open ameliorative relations beyond the habits of human exceptionalism. Think dirt. Do dirt. But because this is dirty theory, the thinking and the doing are messed up, and a theorist one day is a practitioner the next, and a practitioner one moment is a theorist the next. Dirt relations are transversal relations. Make a mess, clean it up, accept that the task must start over again the very next day. I have no doubt that Sisyphus was caked in muck and dirt.

Dirt has already settled into some of the crevices of architectural research, whether through a fascination with dust, or weathering, or with what David Gissen calls architecture's "other environments", to which he offers a name: "subnature" (2009). This is a name presumably meant to designate that which comes from below or which operates from beneath the domain of proper disciplinary conventions, and this begs the question: Do subnatures subconsciously structure our disciplinary habits, and our behaviours, too, in relation to our habitats? Gissen makes no recourse to Sigmund Freud, more politely presenting a series of architectural projects that admit a fascination in the dirt of the subnatural, from the work of *enfants terribles* François Roche and Stéphanie Laveux of R&Sie(n) with their speculative Bangkok tower, B_Mu, which was designed to attract rather than repel the polluted air (Gissen 2009, 79), to Jorge Otero-Pailos's iterative experiments in the reappropriation of dust, which test the radical preservation of architectural surfaces (Gissen 2009, 95-99).

While Gissen does not venture to mention Freud's tales of what may lie beneath conscious consideration when it comes to dirt and architecture, Bloomer certainly does, and Haraway likewise points out that Freud can act as a guide to understanding the traumas associated with the conceit of human exceptionalism (Haraway 2007, 11). No doubt dirt of various

kinds has been at work in architecture from its dark beginnings, registered in the first moment that some dirt was cleared to create the ground on which human life could commence its performances. Some ground is cleared, a circle is demarcated, what is considered foreign is removed and as a result a rarefied space is secured. In his own meditations on pollutants and dirt, *Malfeance: Appropriation Through Pollution?*, Serres argues that dirt and its distributions play a fundamental role in relation to the basic questions: "How do the living inhabit a place? How do they establish it, recognise it?" (2011, 2). He answers: "*appropriation takes place through dirt*" (3; italics in the original). Through the scent-signs of our personal stains, body odour, urine, "perfume and excrement" (2), we demarcate territories, venturing to make them our own. We spit into the tasty soup so that no one else will eat it. Dirt admits a spatiality in the simple observation that other people's houses do not smell quite right, because they do not smell like home.

When addressing dirt in relation to architecture and art, a detour through the formless becomes inevitable. Here, the proper name of Georges Bataille necessarily enters the frame of reference, followed by mention of Yve Alain Bois and Rosalind E. Krauss's exhibition at the Pompidou in Paris (1996) and the subsequent book *Formless: A User's Guide* (1997), which was supported by their thinking with

Bataille. It is worth noting, though, that Bloomer's experimental work *Architecture and the Text: The (S)crypts of Joyce and Piranesi* also draws on Bataille and was published some four years earlier (1993). Acknowledging the long relationship between dirt and artistic expression, Bloomer quotes Mark Taylor on Bataille. In reference to a meditation on the ancient cave paintings of Lascaux, Taylor reports: "From the beginning (if indeed there is a beginning), there is something *grotto-esque* and dirty about art. Bataille is convinced that the dirt of art's grotesque, subterranean 'origin' can never be wiped away" (cited in Bloomer 1993, 50). Note especially the grotty textual invention of *grotto-esque*. Despite its title, with its apparent emphasis on textuality, Bloomer's artfully composed (s)crypts, and her other essays, reveal a distinctly dirty underground, including dirty ditties and lewd allusions to the dirty stuff that the passageways between architecture and text inevitably reveals. A perhaps unknowing companion thinker to Douglas, Bloomer meditates on the intimate relations cohering between the sacred and the profane, concluding that architecture "actually *represents* the 'filth of the sacred'" (1993, 50; italics in the original).

The essays that are collaboratively and individually signed by Bois and Krauss in *Formless: A User's Guide* are instructive in terms of dirty precedents. They cut a cross-section through representative

samples of the performances of the formless in art and architecture. Included, for instance, is Gordon Matta-Clark's infamous intervention *Threshole* (1973) (Bois and Krauss 1997, 190). Folded into Matta-Clark's title is the temptation to allow for a slip of the tongue, turning it into a dirty word: arsehole. No doubt such controversial quasi-architectural examples, which appear to take things apart rather than construct anything, would not be accepted by those who take a more conservative view on disciplinary taxonomies. The core of the discipline of architecture, as Bloomer explains, concerns building habitable buildings in which to dwell (Bloomer 1993, 33). This architecture is a simple, unified, disciplined and essential affair, much in need of dirtying. In Bois and Krauss's work, the unholy relation between form and the formless dominates, though there is still something rather masculinist and heroic about the celebration of the formless as a will to break down the ordered compositions and surfaces of a world. To break things apart. The formless still tends to organise the mess of materials as something of a side effect necessary to the expression of the formless over form. While there is evidence of the inclusion of dirt, vomit, shit, blood and other satisfyingly repulsive materials in the media of art and architecture, in Bois and Krauss's account these tend to fall under the remit of the powers of the formless. While it troubles their neat distinction, the formless

here does not equate to an overthrow of the form/ matter dichotomy. Questions of the formless are still too caught up in the predominance of form, which accords form a privileged position relative to matter. It could well be simply a matter of emphasis, and in any case it could also be that both Bloomer and Bois and Krauss's textual self-enjoyments merely return us to a somewhat nostalgic recollection of the theoretical fascinations of the 1990s, when the pastel pop of pomo (postmodernism) was beginning to become rather jaded. Only, dirty theory is not afraid of such apparent anachronisms. What the dirty theorist insists is that when we dismiss something – a work, a text – as 'anachronistic', we might as well be describing it as dirty and should instead go for a closer feel.

Dirty theory seeks support in the emergence of the environmental humanities, and intersects with what has come to be called feminist new materialism (though the 'new' here ought to be held in suspension, and even placed under interrogation). Dirty theory is distinctly posthumanist in its tendencies toward more entangled human and more-than-human worldly relations and practices of worlding and even an acceptance of everyday contaminations. The philosopher of science and dog lover Donna Haraway is clearly a champion here, though she has her own reservations about the category 'posthumanist', averring instead that we have never been human (Haraway 2007, 3-108).

Genealogical acknowledgements are necessary, and the dirty precedents that are dealt with above presage a distinct turn to material concerns that emerged in the first decade of the 21st century, through edited collections including Katie Lloyd Thomas's Material *Matters: Architecture and Material Practice* (2006), Stacy Alaimo and Susan Hekman's *Material Feminisms* (2008) and Diana Coole and Samantha Frost's *New Materialisms: Ontology, Agency, and Politics* (2010). To these, Jane Bennett's *Vibrant Matter: A Political Ecology of Things* could be added, and especially the early scene depicting her encounter with "Glove, pollen, rat [dead], cap, stick" mashed into a plug of refuse in a storm water drain on Cold Spring Lane, Baltimore (2010, 4). Note here, an architectural thinker-practitioner, Katie Lloyd Thomas, leads the brigade toward what matters when it comes to material relations. Plunging further into the murk of a recent theoretical past, I will continue to champion the enduring legacy of Bloomer's work, especially for those brave enough to track a feminist and queer course through the pristine halls of architecture. Trailing blood and guts in their wake. I proffer here that the subsequent impact and uptake of new materialism allows us to undertake a reengagement in Bloomer.

New materialists, especially those with a feminist project, explain that through the 1980s and '90s we had gotten so caught up in textual play and discursive

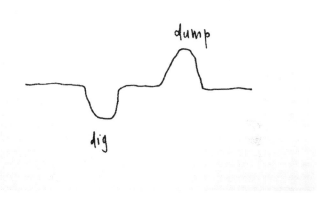

Fig. 1 Hélène Frichot, Dig and Dump. *Drawing, 2019.*

tangles that we failed to remember the materiality of the text and the text's entanglement in specific environment-worlds. As architectural feminist thinker-doer Katie Lloyd Thomas points out, this writing here and now, this book you hold in your hands, assumes a complex array of material supports and infrastructures; it is the "result of a vast network of practices" from the conventions of the English language to "a complex history of development, extraction, technique, transportation and exchange" (2006, 2). That the dirty mess of material matters matter draws our attention to the background, the complex environmental background that is composed

of vast networks of material flows. Consider rare minerals such as cobalt and the outsourced non-Western labour that comes together in this laptop into which I type (Rossiter 2009). In time, this not-so-clean piece of equipment (smudged screen, keyboard messed with strands of hair, skin, dust, even crumbs), will be passed through electronic trash heaps, picked apart again by the small fingers of child labourers who are obscenely relegated to the off-scenes of the Global North. It is worth considering all the livelihoods that are dependent on dirt.

Thinking with dirt means thinking with local and global environment-worlds. No locale rests outside the infiltrations of dirt, and if you don't see the dirt in front of you, it is because it is being collected, held and managed elsewhere. In my dirty drawing *Dig and Dump* (2019) I illustrate a simplistic relation between the resources we dig up, and the trash we dump when we have exhausted the perceived use-value of the things that resources have been ingeniously moulded into. This is an ancient cycle, dig and dump, dig and dump, that has accelerated dangerously following the industrial revolution. I invite you to multiply this thought-image ad infinitum in order to understand the concatenating impact of our collective dirty habits. An urban context that is described as dirty is often one in which layers of infrastructure are dysfunctional and spatial support systems are insufficient for the job.

Dirt troubles architecture and its associated disciplines. Hence the subtitle of this dirty book. If, as Bois and Krauss argue, "The dream of architecture, among other things, is to escape entropy" (Bois and Krauss 1997, 187), dirt can be understood as one of the primary material outcomes of such entropy. Dirt creates resistance to the deceptively smooth surfaces of urban inhabitation, compounding local miseries with global flows.

> The smooth spaces arising from the city are not only those of worldwide organization, but also of a counterattack combining the smooth and the holey and turning back against the town: sprawling, temporary, shifting shantytowns of nomads and cave dwellers, scrap metal and fabric, patchwork, to which the striations of money, work, or housing are no longer even relevant. An explosive misery secreted by the city... (Deleuze and Guattari 1987, 481)

Failure to clean, to wash, to purify, to organise and to tidy results in the world reclaimed as dirt. And yet, we must hesitate here, for failure to maintain houses, neighbourhoods and cities that are falling into disrepair is quickly countered with the demand for 'clean-up' jobs – revitalisations that are supported by the perceived economic benefits of gentrification. The problem is that even to undertake a

friendly, local clean-up job is to risk the collateral damage of social cleansing. Revitalisation and gentrification can bring with them the homogenisation of the social ecologies of neighbourhoods. Things get more complicated, as Ben Campkin has demonstrated, in that dirt, the grittiness of "edgy" neighbourhoods can develop their own aesthetic value (Campkin 2007, 74). Gentrification works with dirt, revaluing it. The complexity and ambiguity, the instability of dirt categories, produce unbalanced and precarious relations between the pure and the impure, the smooth and the striated.

Dirt, it might be assumed, is anathema to technology, but the lifecycle of technological products depends on the extraction of resources, the environmental mess of industrial effluents and the designed obsolescence of technological things that anticipate a future incarnation as trash. Nevertheless, dirt is what we are frequently promised will be removed, should we only apply adequately advanced technologies. The techno-fix is supposed to clean our living environments of dirt. Remain deeply suspicious of anyone who claims to have an answer to your dirt, or who claims that your home maintenance chores can be magically done away with. In his pre-digital discussion of technology through the complex lens of processes of mechanisation, Sigfried Giedion, an architectural historian and critic writing in the 1930s, maintained an orientation toward cleanliness that went so far as

to claim to secure the liberation of domestic labour. For Giedion, gender and technology, when applied to what he calls the "feminist question", facilitates the emancipation of women from domestic toil through the imagination of a "servantless household" (Giedion 2013, 514). Giedion's analysis goes beyond gadgetry to acknowledge the organisation of the spaces and practices of work, including the postures of the house-working woman. While he does not say it as such, what becomes evident are the contagious relations between architectural spaces, technological systems, labouring bodies and the incursions of dirt.

Lewis Mumford, an American philosopher of technology and contemporary of the Swiss Giedion, dramatises another vision of household rubbish by mobilising the mythical figures of Mars and Venus and the "ritual of conspicuous waste" that they perform in the interstices of war and peace (2010, 96). For Mumford, waste is the by-product of the cyclical dynamic between war and leisure time activities, between battle and rest and recreation: "When Mars comes home, Venus waits in bed for him" (97). An unfortunate, rather bipolar, vision. Supine, she awaits the spoils of war and demands her luxuries, Mumford explains. And with the toil of war, the reward is one that is increasingly augmented through advancing technologies, hence what is frequently referred to as the military-industrial complex. Simply, war supports the technological development demanded by advancing industries.

Ursula le Guin throws quite another spin on the ancient Roman figure of Mars in her novel *Lavinia* (2008), where she explains that this cyclical rhythm is rather one between warfare and agriculture. When Mars is not at war, his mortal representatives tend to the fields; when Mars and his men are away, staging battles and border skirmishes (keeping things territorially clean), then the women get to work managing the farmlands. Le Guin's novel explores a feminist reorientation of Virgil's *Aeneid* (29-19 BC), offering an account of events on the ground from the point of view of Lavinia, daughter of Laurentum, King of the Latins, and the Trojan migrant Aeneas's third wife. As more than mere supplement to epic poem, the reproductive toils and rhythms of housekeeping are celebrated here as fundamental to the sustenance of social and reproductive relations. Hélène Cixous and Catherine Clément take this further where they call forth the newly born woman: "She handles filth, manipulates wastes, buries placentas, and burns the cauls of newborn babies for luck" (cited in Bloomer, 1993, 105). Sometimes we need to take hold of the story, entirely reorient it, and tell it again from an entirely other point of view; take it from a point of view otherwise obscured, purposively shoved down in the dirt. Recover it, restore its value. This is something that Ursula le Guin does well.

Returning to dirt and technologies, in Mumford we encounter an ambivalent view of machines, instruments

and systems, which, like dirt, and regardless of their scale or level of complexity, can be good and bad for you. "It [technics] is both an instrument of liberation and one of repression" (Mumford 1934, 283, cited in Genosko 2015, 8). Félix Guattari, influenced by Mumford's concepts, likewise asserts: "The machinic production of subjectivity can work for the better and for the worse" (1995a, 5). Technology is understood here as something integrated into the everyday activities of human (and non-human) bodies, and not as that which is outside or independent. Dirt is the grease and the grit that contaminates the boundaries of bodies-technologies. The leftovers, the becoming redundant of old technologies leaves waste in its wake: "Beside the few ingots of precious metal we have refined, the mountains of slag are enormous" (2010, 106), Mumford comments, though his hope is that from the slag heaps we may yet discover some value. These are some of the troubles of our vast and energetic industrial toil. The so-called, and oft alluded to, geological era of the Anthropocene is one attended by waste, rubbish, pollutants and dirt. We are in the dirt, and the dirt, from micro-plastics to insecticides, is in us, as we are increasingly discovering.

From the digging of foundations and laying of groundworks, via the collection of cobwebs and dust in the crevices, nooks and crannies of architecture, and all the way to instances of demolition or the gradual progression of decrepitude, dirt is a glue,

a sticky substance that holds architecture together and causes it to fall apart. Dirt includes gossip: Who has the dirt on whom? What will paperwork trails, archives and histories reveal? And what of the anecdotal stories we tell ourselves of our discipline and practice? When we get 'the dirt' on someone, we contribute to the circulation of gossip, and as Keller Easterling argues, gossip, rumour and hoax can be used to destablise power (Easterling 2014, 215). Such critical tools can be used by the politically oppressed, but tools, including concept-tools, can be taken up by anyone, "the powerful as well as the weak" (216), and applied to both creative and destructive ends.

To trouble architecture, to undo its categories, its exclusions and inclusions, I seek advice from feminist philosophers Judith Butler and Donna Haraway. Where Haraway calls on us to stay with the trouble of our dirty worldly relations, Butler troubles gender, alerting us to how messy identities really are and how trouble is always bound up in prevalent power relations (1990). Judith Butler's *Gender Trouble: Feminism and the Subversion of Identity* (1990) exploded out of the late 1980s, challenging any assumptions about achieving a biologically essentialist fix on sex or a universal and stable identity for gender. Gender is wilful, performative, apt to pervert the course of conventional categories: it makes trouble. There is nothing universal about ascriptions of gender identity imposed on unwilling

subjectivities by way of societal norms. The convenient definitions of sex, understood as biological, and gender, understood as culturally constructed, are likewise muddied by Butler. Not even the body can be taken as a given, because it admits its own genealogical trajectory. In fact, Butler makes reference to Mary Douglas to challenge the notion that the body is a hermetically sealed unit, understanding instead how the body is apt to be contaminated. Where the impermeable virginal body is raised up as an ideal, we should watch out for the violence to follow (Douglas 1966, 159). The boundaries of the body, of all bodies, must be re-drawn, but with a line that acknowledges leakage points and the playfulness of drag performance, poking fun, telling dirty ditties at the expense of those who would wish us to be clean, ordered and decorous.

The introduction to *Architecture and Feminism* (1996) opens with a quote from Butler on the strategy of exclusion: "What is 'outside' is not simply the Other – the 'not me' – but a notion of futurity – the 'not yet' …. Will what appears as radically Other, as pure exteriority, be that which we refuse and abject as that which is unspeakably 'Other,' or will it constitute the limit that actively contests what we already comprehend and already are?" (Butler cited in Coleman 1996, ix). The simple moral of Butler's pronouncement is as follows: What we expel, the dirty, the abject, is exactly what composes us, what we already are. Coleman cites other feminist

philosophers too, such as Elizabeth Grosz and Luce Irigaray. If the 'absence' (of women, the Other, any 'other') at the centre of the discipline demarcates a place cleaned of clutter and mess, then this noise and dirt, which is part and parcel of "the lived difficulty of everyday life" (Butler cited in Coleman 1996, xv), must be restored. Like housecleaning, the work of restoring minor voices in architecture, design and art, as elsewhere, is unending. Elbow grease is required. Troubling expectations, the result of our taking the trouble to work from the midst of our murky environment-worlds, can benefit our modes of creative practice.

As Butler's work tracks its trajectory through later essays and books, the focus on gender, the performances of subjectivities in process and the emphasis on cultural constructivism eventually lead to a politics writ large at the scale of infrastructures and their spatial support systems. Acts of troubling here locate subjectivities in performative collective formation and spaces in the midst of being made and unmade in intimate embedded relations. A performing subjectivity is a collective subjectivity that is demanding a public space in which to enunciate its concerns. Closing down or restricting spaces of public gathering is an act of cleansing that obviates creative possibilities for new forms of life and living together (Butler 2014; 2016). Infrastructures emerge as a theme in Ben Campkin and Rosie Cox's edited

collection, *Dirt: New Geographies of Cleanliness and Contamination*, according to hierarchies of the low and the high, specifically drawing attention to how the subterranean depths hold and channel the filthy effluents of a city (2007). These are the infrastructural systems upon which we depend for our wellbeing, and they must be understood as socio-technologies, which bind technology and technics with subjectivities. Supporting some, letting others fall and fail.

It is toward thoughts of our environmental 'entanglements' that Donna Haraway likewise leads the reader in *Staying with the Trouble: Making Kin in the Chthulucene* (2016). Here, trouble leads directly to the central importance of dirt; to soil and compost and how to work and think with multi-species critters out of which we humble humans are also composed. Haraway looks for "humus-friendly technological innovation" wilfully combined with "creative rituals" (2016, 160), a gesture toward dirtying the presumed purities of scientific objectivity, and what she has in her earlier work called the 'God trick'. We are always in the shit, we cannot presume to be looking at it from a privileged position high above or from a position that is omniscient and thus nowhere. Dirty theory places us in it, where we already are, groping darkly about.

Haraway speaks of tentacular thinking and story-telling, and of projecting an alternative vision of our

current epoch under the title "Chthulucene". Offended that, yet again, the figure of man, as designated by the Anthropos, is used as primary marker of the Anthropocene, Haraway counters this conceit with her denomination of the Chthulucene (2016). Dirt participates in the hybrid, the monstrous and the improper, and Haraway's alternative figure resembles nothing Vitruvian. No such perfect human figure, the Chthulucene is more terrifyingly Medusa-esque, with tentacles and slippery, multiplying limbs. It is a counter-figure that is supported by a counter-narrative, able to collapse temporal matrices and to tell other stories. It disrupts hierarchies and plunges us into the dirt, the slithering of worms, the haptic grasping of tentacles, the mucky celebration of multi-species, non-human relations. The Chthulucene is both monstrous figure and geological epoch, both/and. Haraway's counter-concept for a geological epoch figured otherwise is drawn from a story by the African American sci-fi writer Octavia Butler (Haraway 2016, 119) about how we find ways out of destroyed environments, and reduced relations. The heat of the humus pile is where Haraway argues we get dirty, because "we need a hardy, soiled kind of wisdom" if we hope for worldly, human and non-human recuperation (Haraway 2016, 117). Less abject than joyous, it is a dirty melée that we find ourselves within. Haraway calls the world 'Terra', earth, dirt. She borrows this act of naming from another science fiction writer, Ursula Le Guin. Haraway's mobilised acronym

SF (Science Fiction; Speculative Fabulation; String Figures) encourages a hands-on approach to staying with the trouble of local and global worlds. We have to be able to tell a good and dirty story, even mutter a few dirty words, to infect the habits of thought of those who have become too complacent, unbelieving or disengaged. Contamination is not all bad, as Anna Tsing has argued in her journeys with mushrooms to the ends of the world (Tsing 2015). "We are contaminated by our encounters, they change who we are as we make way for others" (27), a proposal that looks to the value of passing knowledge along and making way for future generations, as well as acknowledging the eventual decay of the body once it has seen its life through. Relations of contamination are both material and semiotic.

There are theories of dirt that have been propounded from Douglas to Campkin and Cox, and explored via alternative narratives and practices from Bloomer to Haraway, but what happens where we warily mobilise dirt as its own kind of theory? Dirty theory? Again, this is nothing new. Katherine Shonfield has done it with goose feathers, writing and wit (2001). Dirty theory is a hand-me-down, worn-in, a little grubby. By intersecting with dirty thinkers and dirty doers, I'll attempt to muck out a few concept-tools that might belong to this thing called dirty theory. Following Douglas, and listening to Campkin, where possible I will attempt to maintain

a mundanity of metaphors (Campkin 2012). Simply, I should keep my figurative language a little grubby.

What can theory do, anyway? It comes before and after the subject matter under consideration, operating as a speculative gesture in anticipation, or else a means of critical reflection after the fact. When theory gets dirty then it begins to work *with*, from the midst of what you are doing, from the midst of the situation that is being analysed, designed, discussed.

What does dirty theory do? Dirty theory contravenes disciplinary boundaries. Dirty theory is impure. Dirty theory moves in ways that are not very decorous. Dirty theory mixes meanings and matterings (always has). Dirty theory disrupts norms. Dirty theory, like any theory, is apt to be abused and done badly, and is peopled as much by the disreputable as by the earnest. It is important to see where dirty theory has become toxic, and it will continue to be important to explore how dirty theory can be creative. Moving from theories of dirt to dirty theory has been a way for me to test a mode of thinking and practicing from the mess of our Anthropocene epoch, of inventing dirty theoretical operations from knee-deep in the dirt. Again, Douglas opens up a glimmer of hope, reminding us that from our multifarious situated engagements with dirt, as subject matter and approach, something creative may yet be fostered. She asks: How does dirt, normally condemned as destructive, become creative? (Douglas 1966, 160).

Chapter 1
A Dirty, Smudged Background

The primary reader on dirt, *Purity and Danger: An Analysis of the Concepts of Pollution and Taboo*, which was first published in 1966, was bequeathed to us by the ethnographer Mary Douglas. That this is the work of an ethnographer should be a reminder that in pursuit of an adequate approach, we must remain close to the ground, listening, not being quick to make assumptions, not judging pre-emptively. Ben Campkin and Rosie Cox, who dedicated their edited collection *Dirt: New Geographies of Cleanliness and Contamination* (2007) to Douglas, subsequently address this material-concept, dirt, from the point of view of geography, thereby expanding social considerations of dirt in order to address its spatial qualities. Dirt, they explain, "slips easily between concept, matter, experience and metaphor" (1). It gets into the gaps, troubling the distinctions by which we attempt to order and control a world. Campkin and Cox's project aims to update theories of dirt with an emphasis on their spatial implications, and as a means of analysing societies and spaces in their complex relations to dirt.

Plotting a theory of dirt inevitably means passing through the work of Douglas, and paying respects to other dirty theorists on the way. It is, for instance, in the shade of STS (Science Technology Studies), feminist new materialism, and the feminist post-humanities together with the emergence of the environmental humanities, that the importance of

dirt becomes even more pressing, reminding us as it does of the material stuff and relations of our environmental milieus. In this way, dirt alerts us to our situated positions and what Peg Rawes calls "relational architectural ecologies" (2013). Architecture, design and art, the creative disciplines generally, those disciplines embroiled in ethico-aesthetic concerns, inherently establish an attitude to dirt. All those processual practices in which we think stuff though drawing and modelling it, where we think through doing, making a mess in order to understand the implications of the role we play in world-making, need to engage a thinking-doing with dirt.

From her perspective as ethnographer, Douglas argues that by tracking dirt we can gain an understanding of the interconnections and patterning of a world (1966, vii). In her structuralist framework, as she explains it, a desire to purify inevitably alludes to a larger whole, a system, and the dirt you discover must be located, situated and understood from amidst myriad emergent connections and disconnections. Douglas observes that if "uncleanliness is matter out of place, we must approach it through order" (1966, 41), and if we are to understand contexts other than our own, she advocates that we should also be able to critique our own habits, rituals, assumptions and norms. Removing the dirt reveals the pattern, presumably produced by the norm, that orders subjects, spaces and societies.

Without dirt, though, how could patterns and creative processes of ordering be activated in the first place? This is not to say that dirt comes first, but it certainly draws attention to the interdependency of dirt and acts of cleaning – what Haraway, Barad and their companion thinkers would call "entanglements". Acts of cleansing and acts of cleaning. Surely a distinction must be made, for such acts can lead to violent erasures or creative possibilities in the forging of new relations.

On returning to Douglas's seminal work, Campkin argues that we must take her oft-cited formula "dirt is matter out of place" not as something fixed, but rather as something ambiguous. He warns of universalisation and of the tendency for readers to get stuck on Douglas's formula, understanding it as a binary, when in fact it opens up the deeply ambivalent qualities of dirt. Not all matter out of place is dirt, and dirt certainly has a place, as he remarks, in terms of our systems of organisation of societies and worlds. Dirt, filth, abject stuff can all be both a dangerous pollutant and something valuable, even incorporated into sacred rituals, as Douglas demonstrates. Dirt is contradictory, complicated and restless. We must attend to dirt on a case-by-case basis, accepting its situated contingencies. When we locate what we would define as dirt or dirty, it can be discovered in places where it would appear to belong: in the rubbish bin, the waste dump, the sewage plant, spaces

of ablution. (As a friend recently pointed out to me, when my baby shits in its diaper, for sure the shit is dirty, but it belongs there; it is only when the diaper leaks that the shit becomes dirt, matter out of place.) There is the emergence of dirt, the event of dirt taking place at the moment of failure – the temporal aspect of dirt. Ablutions must be continually cleaned away; the waste dump will reach maximum capacity, and so on. As quick as the will to catalogue and classify dirt may be, the emergence of new forms of dirt is quicker. The long list of dirty things, by which an attempt is made to order dirt, is unending, its composition demanding a conceptual labour that would be perpetual.

Dirt confronts us with the radical contingencies of experience, and yet this is not to say that such a confrontation should be abysmal. When we dig deeper into Douglas's *Purity and Danger*, in fact we find that the formula is derived from the work of the pragmatist philosopher William James. Douglas explains this, quoting James at length in a passage that concludes as follows: "Here we have the interesting notion... of there being elements of the universe which may make no rational whole in conjunction with the other elements, and which, from the point of view of any system which those elements make up, can only be considered so much irrelevance and accident – so much 'dirt' as it were, and matter out of place" (William James cited in

Douglas 1966, 165). That which disrupts systems and threatens the infrastructures that support everyday life, which undoes social relations and causes political unrest, which lacks sense or threatens a milieu (social or otherwise) with nonsense, irrelevance and accident, belongs in the category that James defines as "dirt", held in the containment of his inverted commas.

James is a thinker that Deleuze and Guattari have drawn upon in establishing their ethics of difference, specifically borrowing James' concept of a radical empiricism. What is a radical empiricism? It is an onto-epistemological position that situates all life as unfurling in a state of continuous flux from which identities and states of affairs emerge, and into which they dissipate. In the midst of this field of immanence that is life, the subject-environment assemblage persists as "a *habitus*, a habit, nothing but a habit in a field of immanence the habit of saying I" (Deleuze & Guattari 1994, 48). Sheltered here is a message concerning the profound imbrication of subjectivities in formation and dissolution amidst environment-worlds, one bound up with the other in reciprocal relay. As will become evident in the small chapter below dedicated to dirt and differentiation, Douglas and Deleuze can be placed in dialogue around the question of dirt and an ethics of difference, that is, the complex conjunctive and disjunctive entanglements of subjectivities, environ-

ment-worlds and things. Importantly, when we frame this discussion around the subject matter dirt, we find that the contingencies of a radical empiricism, less than creating out-and-out chaos rather diversify situations and points of view in a pluralistic way, so that from the seething flux of existence, creative forms of life may yet emerge. It is out of the chaos, furthermore, that novel concepts clamour for existence. To demonstrate such complex concepts and harried relations, a sited example may be of use, and Peg Rawes can poetically lead the way.

In her edited collection *Relational Architectural Ecologies* (2013), Rawes opens her own chapter by inviting us to bear witness to a landscape vista. Across a field of wheat gently swaying in the breeze a woman walks. She makes her way with quiet purpose. The artist Agnes Denes and her team undertake the labour of care of planting a wheat field on the site of a former waste dump, Battery Park, in New York, and the project in question is called *Wheat Field: Confrontation* (1982). The iconic image that is disseminated of the work depicts Denes walking calmly with a stick through the wheat field, and in sharp contrast rising up in the background are the skyscrapers of New York. The confrontation alluded to in the title operates in a number of ways: wheat field juxtaposed with dense, energy-hungry and waste-producing urban context; former trash heap remediated as wheat field; food crises contrasted

with greed and wealth, the financial capital of Wall Street just a block away. As Rawes argues, at work in this demonstrative performance and its contribution to a women's environmental movement in art are social, material and technological systems intertwined in durational flux across what could be called a field of immanence (2013, 44). From the dirt of the massive waste dump of Battery Park, the remedial promise of a wheat field blooms, and with the dirty smudged background of advanced capitalism looming in the background such ecological relations exude a dirty resilience, though they continue to be threatened. The confrontations themselves yield transformations, both constructive and destructive. At work are the complex relational ecologies of human and non-human subjectivities and environment-worlds. The wheat field sprouts as a moment of interference in the otherwise smooth operations of Integrated World Capitalism.

Chapter 2
Dirt, Noise and Nonsense

Noise is the source of all creativity. We hear this in the murmurings of both Michel Serres (2007) and Gregory Bateson (2000). Noise is nonsense, nonsense threatens disorder. From disorder emerges the compulsion to make some kind of sense, however scant and provisional. Dirt is matter out of place, that is, stuff in a state of disorganisation: "Reflection on dirt involves reflection on the relation of order to disorder, being to non-being, form to formlessness, life to death" (Douglas 1966, 5). There are both cosmic and social pollutants, Douglas observes (74). Operating in complex interconnection, there is more and there is less mundane dirt. There is dirt that is symbolically assigned, and there is dirt that we don't always clean up after ourselves. Between the symbolic, the semiotic and the material there are relations that cohere, get sticky, leave behind marks and stains. This sticky relationality of the material semiotic likewise pertains to the relay between sense and nonsense, between the communicated message and what is too readily discounted as noise. It also pertains to the fruitful relay that travels like a shuttle between theories and practices, an animated, ever-mobile relay that the dirty theorists presented in this small book subscribe to.

In *Sense of the World*, Jean-Luc Nancy offers a small etymological dance around two key terms, the world and the unclean, observing that *le monde* (the

world), can be associated with *immonde* (unclean). He speaks of a world heavy with suffering, disarray and revolt (Nancy 1997, 9). It might be worth hesitating in order to ask, though, what is the worth of this clever word play unless our feet get dirty while doing the dance? It has to matter, the textual play must lead somewhere, toward some shift in our practices, some recognition of the significance of our worldly ecological relations. Surely, there must be something grounded at stake? The sense of the world is unclean, which is to say, it is smudged and obscure, not clear and distinct. Clarity can be extremely dangerous. Clarity can have the stink of death about it, for it allows no compromise, no alternative visions, however indistinct and unsure. The sense of the world works in partnership with the nonsense of the world. Sense and nonsense, Deleuze observes when he follows the adventures of Lewis Carroll's Alice, are like the reverse and right sides of a single cloth, mixing sensations of bodies with trajectories of sense (1990). At the near intersecting, asymptotic trajectories of sense and nonsense events erupt, and something (rather than nothing) takes place.

Returning to Douglas and James's formula, noise and nonsense can be defined as information in the wrong place. There are grave dangers and risks here. A fake fact is information 'out of place', but implanted in such a way as to produce dire contaminations to collective modes of thinking together.

Fake facts are intimately intertwined with the ideas we pass back and forth like dirty coins, and the practices these ideas are embedded in; they participate in the establishment of the normative frameworks that constrain our thinking and doing, transforming our enunciations into mere platitudes. The insidious side effects of fake facts in architecture (as elsewhere), in our troubling era of alternative truths, get us stuck in the rut of thinking-practising dogmatically. How do we develop adequate critical weapons to think-practise otherwise?

Data management plans, privacy, the eruption of fake facts and alternative truths, all cluster the 21st-Century media-sphere with so much chatter. What is spam, what is junk mail? The message we would otherwise refuse that has arrived in our inboxes to become informational refuse. Sometimes the message gets lost in the junk folder, even though it was news that we in fact wanted to hear. We should not make the mistake of believing that this is merely so much immaterial junk, for it pollutes the delimited spaces in which we are still allowed to think. The sending of empty messages back and forth requires massive material infrastructures. As my colleague Adrià explained to me, every Google search consumes energy and produces pollution as a result.

Sense and nonsense alert us to the sense-making use of concepts, which when managed confusedly

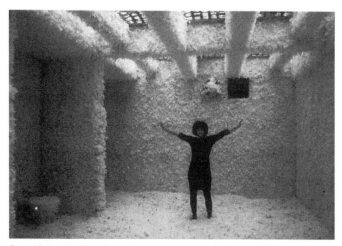

Fig. 2 Katherine Shonfield, Dirt is Matter Out of Place, *1993. View of Feathered Interior, Commercial Street, London. Photograph by Frank O'Sullivan.*

can lead to obscurantisms and the bad reputation of theory work. Bad nonsense, good nonsense, nonsense that closes down, nonsense that opens up new modes of sense. Concepts are dirty because they have been handed around – they are pre-used and prepared for recycling and up-cycling. Take a concept, make it dirtier than it was in the first place. Even seemingly novel concepts admit some genealogy, they don't arrive from nowhere. All concepts are smudged with the dirt of many hands, and a good number of etymological messes. Noise is the interference pattern that turns the message into garbled nonsense, and yet deep inside the nonsense, new modes of marvellous sense-making emerge.

Dirty ditties that pack a punch re-orientate our ways of seeing, feeling, thinking and acting. Beginning in a homophonic transfer from noise to noisome, that which is noisome is defined as noxious, harmful to health, disgusting, insalubrious or unwholesome. Not whole neither. In being not whole, more construction is required, more thinking aroused. The stench might just lead you somewhere.

An image of a woman in a public lavatory. She flings out her arms, ta da! A demonstrative gesture for a provocative project. The walls, the floor, the ceiling of her enclosure, lit from above, are (almost, not quite) entirely covered with white goose feathers. No doubt the distinct, wet smell of ablutions still invades nostrils during this brief feathery sojourn. The white feathers of a great many gooses get in the way of the reading of the hygienic lines of a public lavatory, as Katherine Shonfield gloriously demonstrates in her ephemeral architectural experiments. Shonfield is particularly fascinated in Douglas's description of a "sea of formlessness" (2001, 36) holding perhaps too firmly onto the form and formless divide, a topical theme in the 1990s (Bois and Krauss 1997). Yet soon enough the "sea of formlessness" begins to exude its material affects, and the form/formlessness distinction gives way to the durational passage of a material, sensory mess. Are the goose feathers, seemingly pure and immaterial in their initial whiteness, the noise that obscures the

ablutions of a public lavatory? Or is it that with the slow rot of the goose feathers and their associated animal stench, even representations of purity are shown to be apt to decay? Symbolic ideas of purity can abruptly transmogrify into materialisations that arouse disgust.

To address dirt alongside noise and nonsense directs us towards the sensations of assemblages of bodies, and eventually to an underground 19th-Century lavatory on Commercial Street London, originally designed by Nicholas Hawksmoor. Shonfield explains that after some time, the slowly putrefying feathers that clad this lavatory certainly did indeed begin to stink. White on white belied by incipient stink. Getting so many bags of feathers to stick, only the thickest white wallpaper paste worked, she explains, giving us the dirty details (2001, 42). Offering a brief affective description of the interior of the London Feather Company where her goose feathers were sourced, Shonfield describes how: "The underlying smell of suppressed animal, like shit partially masked by lavatory cleaner, pervades" (2001, 42). The lavatory as facility, as infrastructure, is dramatised by Shonfield according to eras: 1. The Pre-Lavatorial Era; 2, The Evangelical Era; 3. The Era of Regulation and the Division of Labour, and so on, almost as though a geology or natural history lesson were being given. The historical progression, into which the installation is inserted as moment of feathery resistance, concludes,

unsurprisingly, in the era of deregulation. These are lessons that wilfully mix nature and culture, revealing in the process the dirty beginnings of gentrification by means of which the lavatory subsequently becomes an elegant neighbourhood wine bar. Filth finally bleached and scrubbed and washed out, so we can sniff the terroir of the juice of the grape.

In Shonfield's discussion, her temporary, experimental projects are foregrounded, while the theoretical discoveries unfold later as she follows the implications of her material compositions. She explores theory through practice, attempting to understand how much 'meaning' or 'sense' architecture can hold. Her projects are dirty as they challenge clarity – that is, the clarity of a plan of action, the outcome of which is known in advance. For instance, Shonfield explains that the analogy of being tarred and feathered only occurred to her on reflection, after the fact. Dirty theory applied to creative practices allows for discoveries post facto, for projects keep on accumulating the dirt of discourse. Unafraid of a haptic grasp, and reading Douglas, like so many of those who venture to look closer at the dirt, Shonfield is able to ask how far architectural purity is defined by the unambiguous classification of its elements, and the organization of knowledge according to acceptable disciplinary diagrams and procedures.

Shonfield is known for her collaborations with muf art/architecture London, a practice that is proud

to render visible its 'family tree' of collaborations (muf art/architecture n.d.). Muf, a dirty word for a creative practice if ever there was one. Some hesitation is warranted here, when we remember that dirt is that which can be pre-emptively pushed to the side, out of sight, out of mind. As feminist practitioners and theorists, we must ask whether we risk marginalising our creative labours by maintaining our temporary, incidental and site-based projects at the periphery of the domain of architecture. On a spectrum of dirt, between the material and the semiotic, between the established and the marginalised, what balance can be secured so as not to contribute to the ongoing dismissal of the reproductive labours of architecture? How do we insist, for instance, on the pedagogical and practice-based discoveries of such ephemeral works?

The feminist philosopher, architect, poet must always struggle against the grain of existing discourses and practices, and their ingrained assumptions, in order to undertake her own work. Philosophy is always already claimed by the master's voice, or as Moira Gatens puts it, even feminist theory depends too much on what is always already a value-laden discourse that has as its dirty depths a devaluation of women (Gatens 1991, 2). We assume the inherent neutrality of the theory being used, but it is more grimy and smudged than all that, carrying contagions into our modes of thinking that decompose the value

of our own contributions. While I'd love to imagine a fast-paced and dirty gonzo journalism for girls, I must admit that this approach risks simply following an established masculine model. So how can those held captive under dominant order-words find voice? How can the dirt be pushed to the centre of attention, and not be merely relegated to the margins, off-scene, eccentric, outside and elsewhere? This dirty theory that I am mobilizing here – after Donna Haraway and her companion thinkers, and after Jennifer Bloomer and her dirty ditties and drawings, and after Shonfield and her feathery excesses – insists on a material semiotics. It insists that smatterings of dirty material stuff, dirty concepts and dangerous work must all be attended to. Sense dances with nonsense, while accepted discourse is splattered with the white noise of garbled information. Meanwhile, the marginal, the overlooked, the undervalued, the minoritarian voices scramble to reorient priorities and points of view. The promise of elaborating a dirty theory is dedicated to allowing just that, reorientations whereby the margin becomes the centre.

Chapter 3
The Dangers of
Purification

What is lost when we clean away the dirt, when we brush all that unwanted detritus under the rug? Grave dangers to the arts of thinking, of noticing, of paying attention are presented, when too much is disinfected. In any case, as Douglas is keen to observe: "As we know it, dirt is essentially disorder", only in the next breath to assert: "There is no such thing as absolute dirt: it exists in the eye of the beholder" (Douglas 1966, 2). This is admittedly something of a confounding statement, in that dirt is given its essential meaning in disorder, and yet that essential disorder is allocated depending on your particular stance and point of view. Dirt becomes relative to position and situation. Your dirt, my treasure. Your disgust, my joy. A more insidious observation is embedded in this message, and it concerns the power vested in the one (or several) who perceive and take it as their right to categorize what is dirty and what is clean. Pure reason must be challenged where that reason proves exclusive or remains inaccessible to the many. If another island is to be sought, it is one upon which all our bare feet should be allowed to wander.

It is in his book *We Have Never Been Modern* that Bruno Latour delivers a lesson that many feminists have laboured to deliver, this time with a stress on the dangers of purification (1993). Latour cautions that we get ourselves into real trouble when we

attempt to purify, to categorize, to compartmentalize and to place concepts in silos. Such acts can be understood as conforming to what Bloomer calls a bipolar logic. Bipolar logic, a mess of mind and matter, "demands an inferior and a superior term, structures Western thought, demarcating binary categories in which one term is privileged over the other. Light and darkness, male and female, theory and practice, culture and nature, creation and pro-creation, sacred and profane, mind and body, speech and writing" (Bloomer 1993, 8). Yes, yes, I hear you complain, we've heard it all before, we took our lessons in the dominant and the denigrated signifier in the 1980s and 1990s. A bipolar logic seeks to maintain the purification of categories, but throws out way too much trash in the process, which might instead lend itself to recycling. We need to continue to repeat these lessons, for the process of cleaning things up is relentless.

For Latour, the word 'modern' designates two sets of practices, one pertaining to translations between nature and culture, and the second pertaining to purification, whereby distinct ontological zones are determined for humans and non-humans (Latour 1993, 10-11). Our maintenance of the conceit of a modern standpoint requires that these two practices are kept separate. On the one hand, translation produces a proliferation of hybrid beings; on the other hand, purification, as though in ignorance or denial

of this seething proliferation attempts to make only distinctions: us and them, modern and premodern. If we are to breach the 'Great Divide' between these practices, then what will be needed are new forms of democracy, which Latour goes on to elaborate in his essay "Why Has Critique Run Out of Steam? From Matters of Fact to Matters of Concern" (2004). Rather than recommending an abandonment of critical theory, as might at first appear to be the case, instead Latour uses this oft-cited essay to offer a prognosis. The steam here is a reminder of the socio-technics of thinking, machinic machinations animating technological infrastructures that support and hinder the project of critical theory with its emancipatory ambitions. If we liberate how we think the world, his argument goes, perhaps concurrently our practices and actions can be transformed and new collective political modes of getting along together might be imagined. The upshot of this is that critical theory needs better weapons. Dirty bombs to shatter oppressive forces. Keller Easterling stresses that the tactics and tools associated with gossip, rumour and hoax can be mobilised by the weak and by the strong (2014, 216); once taken up, no concept-tool remains innocent for long.

Better weapons carry the risk and promise of reducing things, including dirt, to rubble. Dirt might be associated with debris, but not when debris is raised to the status of the romantic fragment, with

its ache for a former state of wholesomeness. The wholesome whole. Dirt is less than debris, for debris still hark back to something regal and upright, a proper past or a monument that has been destroyed, as in the sad remnant of some cataclysmic event that has befallen an architectural edifice. David Gissen explains that debris describes the scattered remnants of a former built edifice, rubble, atomized parts, fragments that may yet be archeologically valuable (2009, 132). Dirt is not this, it offers more troublesome resistance. Dirt resists the temptation to rarefy, to make special, to return to museological enclosure. Reading Gissen, it is clear to see that debris, understood in terms of the architectural fragment, is apt to rediscover its value once properly placed. Dirt is rather the unwanted stuff that coats and mucks the architectural debris. A second-order debris? No, always something less. Unlike the fragment, dirt was never whole to begin with.

Perhaps dust comes closer. Gissen draws attention to Ruskin's critique of restoration and the will to clean away the expanses of time that are registered in the thickness of an accumulated dust that has become dirt. Dirt collects all anachronisms. Dust is another category belonging to Gissen's account of the subnatural. Yet even dust has become too special, too rarefied, associated with Giovanni Piranesi's etchings, Marcel Duchamp's *Large Glass*, even with sleeping beauty cloaked in the dust of

years as she lies dormant, and with the experiments in critical preservation of Jorge Otero-Pailos. A territorialisation of dust for aesthetic purpose makes material poetic. Dirt is not exactly dust either. It is lower, somehow, in an imaginary hierarchy of stuff and matter; at the same time, in being dirt it does not respect the will to taxonomic order – it will not be so contained. "Accreted dust eventually registers as dirt, then soil, and eventually earth itself" (Gissen 2009, 88), which is to say, detritus pertains to matters unstable, and Gissen wills dirt to redeem itself. Soil is not dirt, and yet the future of dirt may furnish such possibilities. Consider Agnes Denes' field of wheat, for instance. Or else, on the other hand, as Douglas explains "a long process of pulverizing, dissolving and rotting awaits any physical things that have been recognised as dirt" (Douglas 1966, 161). To 'recognise' suggests a mode of making sense, of placing something into an order of things, and when we define dirt, we finally give it its place.

When I wipe away the filth, what will I find? Could it be that once the dirt is cleaned away, nothing will be left behind? Was it all dirt in the end? Is it less a matter of cleaning away the dirt and achieving complete purification than maintaining adequate and caring practices of maintenance? We need enough dirt, and in any case, life is not possible without it. "Purity is the enemy of change, of ambiguity and compromise" (Douglas 1966, 163). At its worst, the

quest for purity establishes problems that are ill-formed. Compromise is the promise we extend to each other to come together, to work through our ever-changing environmental problems. Together we must ask: How do we decide when it is best to creatively resist the rarefication of dirt and stay instead with the trouble of the unwholesome relational ecologies of dirt?

Chapter 4
Dirt and Maintenance

When addressing matters of dirt, much as one ought to pay one's dues to Douglas's ethnographic forays, and to acknowledge Campkin and Cox's cultural geographic contributions, and perhaps nod to David Gissen's more recent discussion of the dirty histories and practices of architecture's "other environments" (2009), and then not forget to return to the dirty ditties and drawings of architectural theorist-practitioner extraordinaire Jennifer Bloomer, I would insist that acknowledging the (sustained and seemingly inexhaustible) feminist maintenance art of Mierle Ukeles is also fundamental.

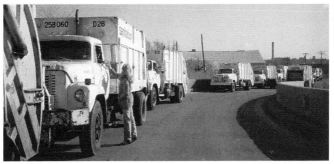

Fig. 3 Mierle Laderman Ukeles Touch Sanitation Performance, *1979-80*
July 24, 1979-June 26, 1980. Citywide performance with 8,500 Sanitation
workers across all fifty-nine New York City Sanitation districts
January 20, 1980
Sweep 5, Queens 60
photo: Marcia Bricker
© Mierle Laderman Ukeles
Courtesy the artist and Ronald Feldman Gallery, New York

What is it that Mierle Ukeles is doing when she publicly shakes the hands of something in the order of 8,500 sanitation workers in New York? Making the profane sacred? Accepting the risks of contamination? Rendering the invisible visible? Revaluing what has been societally undervalued (and certainly underpaid)? It would appear that through her mundane and deeply empathetic performances she is raising the working classes and appointing them a respectable place (should they accept her invitation) in the rarefied annals of art. How far can art succeed in this political act?

Ukeles's famous durational performance *Touch Sanitation Performance* took place between June 1979 and June 1980 across the districts of New York, where much like an ethnographer she followed the daily rounds and rituals of sanitation workers, listening to what they had to say. Her investigation included a further performance entitled *Handshake and Thanking Ritual*, where she solemnly and sincerely shook the hands of the sanitation workers, thanking them for their invaluable contributions to society. As Laura Bliss points out, maintain comes from the Latin root "to hold in the hand" (Bliss 2016), or else, for French speakers it's worth simply noting that *le main*, the hand, helps us compose the word *la maintenance*, maintenance. At issue here, furthermore, is the sustenance of life achieved in these hands-on labours.

Following the relational aesthetics craze of the 1990s and early 2000s, we may in the meantime have become too cynical for such expressions of public sincerity and relational feeling. It's worth pushing back against such fatigue, though, and continuing to locate Ukeles's performances historically and to acknowledge her enduring legacy. Part of the challenge of continuing to respect Ukeles's dirty performances is to hold onto her ethics of care, surely something we remain in urgent need of.

Tirelessly, and with some modicum of humour, Ukeles demonstrates with her works of maintenance that it is not possible to remain within a state of purity, because things will inevitably get dirty. In her book *Feminist Art and the Maternal*, Andrea Liss discusses Ukeles's performances as a series of failed attempts at purification. What is discovered again and again, through each inevitably failed gesture of purification, is a flawed aspiration: "I learned the impossibility of purity – if you become obsessed with it, it can turn into something else. I realized I couldn't control it" (Ukeles cited in Liss 2009, 61). What does an attempt at purification turn into? What violence does it promise?

What Ukeles demonstrates are the unending labours of maintenance – the small and large acts of care and repair that tend to go unnoticed. The work begins at home, where Ukeles photographically documents the daily acts involved in keeping

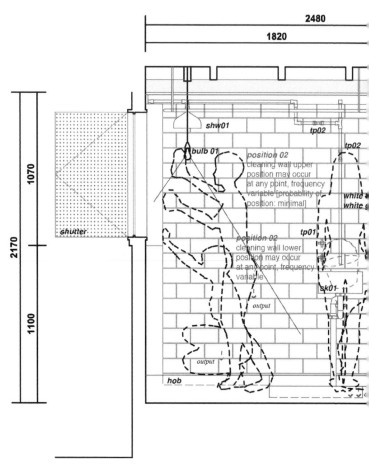

Fig. 4 Zuzana Kovar, The Clinic, *2011-2013.*

660

02

osition 02
eaning floor
osition may occur
any point, frequency
ariable

her own house clean and tidy, which leads to the writing of her 1969 *Maintenance Manifesto*. Work in the home and work on society are not separate, but continuous; this is the pointed argument she extends through embodied display. Some four years before her performances, but after Ukeles's *Maintenance Manifesto*, the radical feminist Marxist Sylvia Federici was taking another approach to the question of household maintenance and hygiene. We might historically locate their respective actions in relation to each other.

Federici famously remarks in her urgent manifesto *Wages against Housework*, "No matter how well-trained we are, few are the women who do not feel cheated when the bride's day is over and they find themselves in front of a dirty sink" (1975, 3). What can we do with this most dire of dirty dilemmas? How can those trapped in the thankless daily rhythms of endless housework be expected to use these very means as a performative line of escape? It could be that in undertaking a playful *détournement* of housework we merely gild the gendered cage. Can the mundane, dirty reality of housework be revalued? Is such a project possible? We must be wary of celebrating our exploitation, Federici warns (6). What we can do is expose what we are already doing, render it politically visible, force the daily household chores to be recognised adequately as work, which in turn requires fair recompense: an adequate wage.

As Federici concludes, "We delude ourselves if we imagine we can escape housework" (8), and while we might be tempted to respond that in the intervening near half-century societal relations have substantially challenged, well, again, we would be kidding ourselves. A snapshot of recent research reveals that women still undertake the greater portion, up to 75 percent, of menial household chores, propping up reproductive cycles of labour in the process (see Vergès 2019). Yes, even today. Bitter resentment is spat foully into many a cleaning cloth.

Bloomer gives us some housework to consider too, albeit of a perverse, performative kind. She offers up an instance of what she calls, after Deleuze and Guattari, A MINOR ARCHITECTURE (capitalised in the original). Relaying a story told by the feminist writer Monique Wittig, she describes a seemingly ritual event in which women collect tools of capitalist culture – mass-produced whitegoods such as washing machines, vacuum cleaners, also a stove – and make a great bonfire of these around which they dance, producing a carnivalesque architecture. This is an event-based architecture that is situated decidedly outside of what would be deemed proper (Bloomer 1993, 34).

There are other, minor, more contemporary instances of housework remade as performative critical gesture. Julieanna Preston borrows from Ukeles to undertake her early morning sweeping of Inspace Gallery during the architectural design research

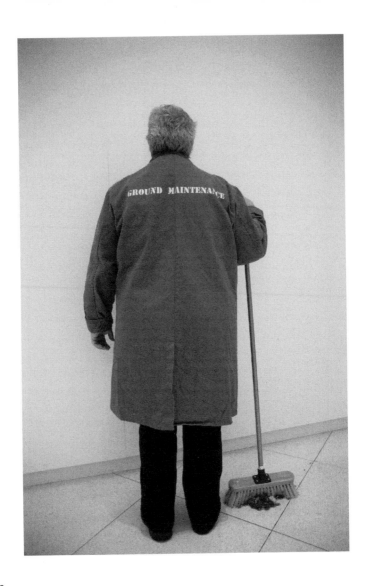

symposium *Plentitude and Emptiness* in Edinburgh, Scotland, in 2013. In *The Clinic* Zuzana Kovar draws an irrational section cut to describe the animated assemblage of domestic spaces, embodied toil and bodily effluents (von Schantz & Frichot 2019). Małgorzata Markiewicz makes much of the trope of the Polish cleaning lady at work in the homes of the affluent, often in places far flung from their own homes and contracted precariously to keep domestic dirt at bay. As Joan Tronto wryly remarks, "dirty work" is most often a labour of care that is relegated to the activities of the underpaid and the undervalued, those associated with members of a lower caste and with slaves (Tronto 2015, 12; Vergès 2019). In the final chapter of this book, Dirt and Decolonisation, it will be important to pay respect to the project of decolonisation in such matters.

When Nancy Fraser raises the spectre of the 'crisis of care', she directly draws attention to boundary struggles over social reproduction, which she deems as powerful as the boundary struggles between classes. The crisis of care, she goes on, is rooted in the "structural dynamics of financialised capitalism" (2016, 116). How does financial capitalism manage its dirt? It fills the care gap by importing migrant workers, by creating social hierarchies.

Fig. 5 (left): Julieanna Preston, Ground Maintenance. *Performance 5:00-6:00 am daily, 4-6 October 2013. Inspace Gallery, Edinburgh. Plentitude and Emptiness: A Symposium of Architectural Research by Design, University of Edinburgh, UK. Photographer Patricia Rueda.*

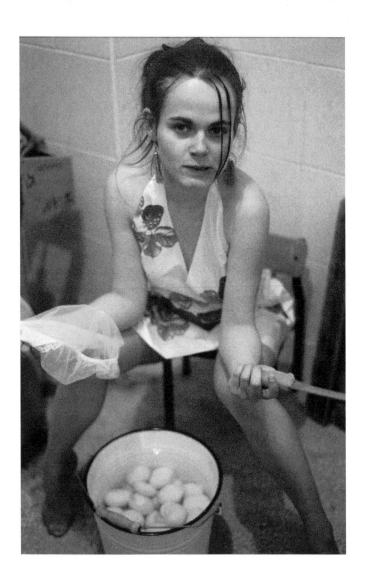

Dirt concerns migrations, the dirt of our place of birth exchanged for the dirt we are to attend to elsewhere. In *The Mushroom at the End of the World*, Anna Tsing argues that: "Everyone carries a history of contamination; purity is not an option" (2015, 27). Much like Douglas, Tsing has been on the ground, spent time working the dirt of stories and relations that expand from local sites of gathering mushrooms to global supply lines along which, in her grounded investigations, the Matsutake mushroom sprouts, issues forth spores, and travels. Contagion is at work in religion and society, and this process of contagion is how Douglas arrives at her promise of the creative potentialities of dirt (1966, 160). Dirt, and dirty theory, can be destructive, but it can also become creative. The work required takes us beyond exhaustion, but we are obliged to be tireless in our collective efforts.

Housework never comes to an end, it starts over each day. As such, it is ritualized. It is repetition with a vanishing margin of difference. No amount of scrubbing, wiping, brushing, sweeping or mopping will be enough. A perpetual motion machine of women the world over. Women and minorities and those judged forever unclean.

———

Fig. 6 (left): Małgorzata Markiewicz, Pinafores, *2001/2002. From the solo exhibition* Can I Make You Feel Bad? *l'etrangere gallery, London, 2016. Photograph by Ewa Olivier.*

I am an artist. I am a woman. I am a wife. I am a mother. (Random order). I do a hell of a lot of washing, cleaning, cooking, renewing, support-ing, preserving, etc. Also (up to now separately) I 'do' Art. Now I will simply do these everyday things, and flush them up to consciousness, exhibit them, as Art. (Ukeles 1969)

Ukeles writes her Manifesto in the late 1960s, and today she is still an (unpaid) artist in residence at the New York Sanitation department. R. H. Horne and Robin Nagle update the story of Ukeles's endless labours of critical care and maintenance when they plot a human history of the trash heap and landfill since the ancient Athenians (2011, 198-205). Ukeles is still at work on Fresh Kills, once the largest landfill in the world, and the site where the debris of the World Trade Centre, New York ended up. Ukeles, Horne and Nagle explain, asks us is to apprehend such trash peaks as collaborative projects. When we look closely, what we see is a reflection of our-selves. The dirty 'commons' our daily trash produces demands ongoing efforts of organisation, care and maintenance.

Chapter 5
Dirty Money

Dirty money is the name given to ill-gotten gains. Money laundering is the dubious means of cleaning dirty money, those ill-gotten gains habitually associated with the criminal activities of the underworld. Money is dirty anyway because it gets handed around. "Don't put that coin in your mouth", the mother says to her child, "it's dirty!" Money is not much because it is everything, the philosopher Michel Serres remarks (2007, 230). Money manifested as an object of exchange, a coin, a bill of exchange, is nothing in its own right, but it does come between us. While it might be exchanged for food, it cannot be eaten: "I shall never be able to be nourished by a language of money, a flat, tasteless language like a big bank note. No smell, no taste, shiny, viscous lots of these are found. When language converges on money, it monotonises its flow; it tends toward the whitest and flattest quasi-object" (Serres 2007, 231). In what follows, dirt, soil and money will clump together into the improbable form of a gold bullion bar to challenge what is deemed valuable to the sustenance of life.

Soil is not dirt. Soil is something valuable, though generally undervalued, for it lies underfoot, or beyond the city limits where its fundamental role in the production of food is taken for granted. I've never been much of a gardener, so there is not much I can tell you about good soil, which means I'll have

to rely on the help of others in elaborating these thoughts. Soil has been heaved up as an important contemporary matter of concern, and because soil is also dirty, it is an apt subject matter for dirty theory. Soiled wisdom goes both ways, because to soil oneself means to get dirty, and to get with the soil means to venture worldly remediation (Haraway 2016, 117). Given time and the right ingredients, dirt may well become soil, at which juncture it would become life-giving. Life – manifesting across diverse forms, soil and seed, augmented by fertilizer and secured through pesticides and the agricultural-industrial complex in which global food production is meanwhile entangled – has become increasingly financialised. What better way of describing the concerted attempts of multinationals to buy up the rights to life, in the shape of seeds and the ingredients that guarantee the productivity of the soil (Shiva 2012; Bella Casa 2017), than an exercise in the ethically dubious domain of dirty money? Shiva argues powerfully that the patenting of life can only be viewed as violence inflicted on present and future communities (121). Looking to the sticky places between dirt, money and soil this chapter returns to an installation at Documenta 13, in Kassel, Germany, in 2012, which sought to unearth what we take to be valuable.

When we entered the Ottoneum Museum in July 2012, where Claire Pentecost's installation *soil.erg* awaited us, the smell of soil, whilst not overwhelming,

Fig. 7 Claire Pentecost, soil.erg. *Documenta 13, Kassel, Germany, 2012. Photograph by Anna Ingbrigtsen.*

was persistent. The days we spent in Kassel, Germany, had been humid and heavy with the threat of rain. An old WWII bomb had been discovered nearby, and the sound of helicopters chopped up the thick air, arousing an end-of-days atmospherics in the general milieu. Kassel is an industrial town transformed into a distributed art venue every 5 years for Documenta. This year, in 2012, at Documenta 13, the theme of the Anthropocene was running filthy, though the organisational concepts were perceived as murky, including eco-feminism and dog calendars and a title that "no one could remember", and some

kind of dance that was "frenetic, animated, clattering, twisted, and lasted a long time" (Documenta 13 2012). Furthermore, it was only the second time that Documenta had been curated by a woman – in this case, Carolyn Christov-Bakargiev. Donna Haraway was included in the hefty collection *The Book of Books: Catalog 1/3* that accompanied the event, where she introduces the multivalent acronym of SF, for science fiction, speculative fiction, string figures (Haraway 2012). Jill Bennett wrote an essay dedicated to the geological concept of the Anthropocene, which remains a thesis yet to be approved as scientific fact today (Bennett 2012). As a recent article in *Nature* notes, while the Anthropocene was informally voted an adequate geological moniker in 2016 at the International Geological Congress in Cape Town, it is only now that the 34-member Anthropocene Working Group (AWG) has solid plans to submit a proposal for the recognition of this geological age by 2021 (Subramanian 2019). In Jill Bennett's essay there is no doubt, however, about the mess we have gotten ourselves into as a result of our furious industrial activities.

We were travelling with our two children and a student of mine who was undertaking preliminary research dedicated to a thinking with contaminated soil. Anna Ingebrigtsen was plotting a speculative remediation project at Vinterviken, Stockholm, where Alfred Nobel had located his dynamite factory in

1865. Yes, that special peace prize that is named after him is funded in part by his massive, explosives-fuelled fortune, which is one way to clean a sullied reputation. Following years of experimentation with explosives on the site of Vinterviken, the waters of which form part of Stockholm's Lake Mälaren, the grounds and the shore became polluted. How do you think *with* the soil? A mapping of contaminants was required. Lead, arsenic and even traces of uranium have been discovered at Vinterviken. Ingebrigtsen's project explored companion planting as a methodology, by attempting to match vegetation to the toxic elements toward the remediation of the soil. With what was left over the idea was to create building blocks. This was her speculative design adventure in which she concurrently sought to tell stories of the site and its overlapping histories. Today there are still signs warning against swimming or allowing your pets to linger too long near the shore.

Following creative contagions of influence, in 2019 Malin Bergman designed a speculative project called *Staging the Labour*. She looked into the work of Ingbrigtsen, Pentecost, Ukeles, and Maria Puig de la Bellacasa's ethics of care to think through a soil remediation project at Barkarby, a former airfield north of Stockholm. Her assemblage of mobile follies manifests an infrastructure of care paying equal attention to human labourers and to non-human soil relations. All of which is to say, working and thinking

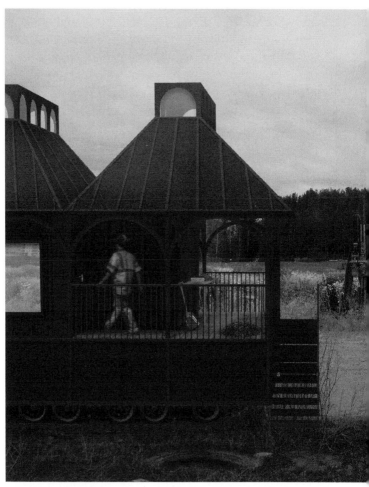

Fig. 8 Malin Bergman, Staging the Labour. *View of the Laboratory, Water Tower, and Crop Storage, Barkarby former airfield, Stockholm. Critical Studies in Architecture, KTH Stockholm, 2019.*

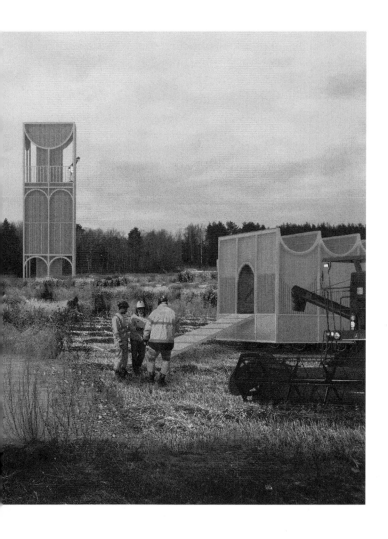

with the spatial implications of dirt can be a joyful experience of contamination.

Back in the Ottoneum, that humid summer some years ago now, umber blocks that in form resembled gold bullion were stacked in piles on two tables laminated in gold. Like some perverse fairy tale, the gold bullion appeared to have transmogrified into dirty soil. Because the soil struggled to hold its form, the luminous surfaces gradually became smudged and marred. The doors of the museum opened directly onto a courtyard, where food from a mobile kitchen was regularly served, establishing the soil-food relation.

Pentecost makes reference to the polymath anthropologist and cyberneticist Gregory Bateson, drawing on his well-known formula that "the basic unit of survival is organism plus environment" (Pentecost n.d.; Bateson 2000, 491). Hence, soil bullion plus seed, environment plus organism, compacted into a unit, a bullion bar, with its distinctively chamfered sides. Embedded in each soil bullion was seed, so that each block would be measured less according to its weight than its capacity to shelter seed. "Planting seeds requires medium, soil, matter, mutter, mother" (Haraway 2016, 129). Seed, surely, is the most compact unit of value upon which life depends to continue its unfurling. The soil, as Pentecost points out, falls apart easily, it is challenging to transport, and in its parody of the gold bullion bar,

her soil bullion bars mess with the abstract logics of economic circulation. The challenge embedded in this critical project is located in the question of soil, of how far it is transformed into a dirty commodity, and how far it resists this commodification.

When the Bretton Woods Accord of 1944, which secured the value of US dollars to gold held in reserve, was cast asunder by President Nixon in 1971 in a bid to control inflation, something dirty came unhinged. As the circulation of US dollars began to exceed the value of gold held in trust, the currency's own attachment to the real, material weight of gold evaporated, and it floated free. Reinhold Martin explains this historical juncture in *Utopia's Ghost*: "in other words the sign had become detached from its referent, or the signifier from its signified" (2010, 64), that is to say, the imbrication of the material semiotic was violently purified. While this severance of abstract value from the material value vested in gold, as well as property, labour, land and buildings, seems like an act of abstraction, it nevertheless has and continues to exude a pragmatic impact on economics. How else did the American subprime mortgage crash come to pass, if not from processes of the purification of abstract value from the material and reproductive value of the lands and buildings on which people's lives depended? Pentecost's *soil.erg* is a speculative project that shows how currency can be grounded again. Her critique casts its web wide,

asking pointed questions about real estate logics and land grabs and about attempts to commodify life through a logic of economic rationalism focussed on processes of financialisation and the God of surplus.

Pentecost writes with elegance of the logics of her soil currency, and how it poses a challenge to our will to financial abstraction, which is quite literally a project of deterritorialisation. Remember *la terre* (earth, soil) is to be found in deterritorialisation. We leave the earth, the soil, behind at our own peril. As Pentecost asserts: "If currency as we know it is the ultimate deterritorialisation, the soil.erg's value is inherently territorialised" (Pentecost n.d.).

An alternative economics is proffered in this simple gesture of soil moulded into the form of bullion. The soil dollar challenges the pre-eminence of the petro-dollar, and questions the anachronistic fixation on gold, attempting to entirely reorient prevalent value systems. Rather than abstraction, the dirty real of our livelihoods are addressed. The exchange rate of *soil.erg* is not pegged to one or another currency, but is materially associated with that upon which our life sustenance depends. "Good soil is alive. Structurally and biologically it is a living system" (Pentecost n.d.). When money is transmogrified as soil, the future promise of nourishment surfaces – a premonition of the panoply of tastes present in the foods supplied from the crops whose growth soil supports. Unless, of course, Monsanto gains full control of the dirt and all

the life sheltered within it. In Documenta 13's *The Book of Books*, there was the notable inclusion of an essay by seeds activist Vandana Shiva who discusses the Monsanto claim on seed, which is an avaricious claim on the life of the commons, or what should be held in common and remain accessible to all (2012).

Mounted on the walls surrounding the table loads of soil bullion were hand-drawn *soil.erg* bills celebrating the thinkers who Pentecost calls on for support. One such bill includes an image of the feminist philosopher of science Donna Haraway and her dog Cayenne. As well as the *soil.erg* bills, soil disks and soil bullion, there was a geological cabinet that offered shelter to a worm farm, where worms were invited to take up residence for the duration of the exhibition. The worms fed off the scraps from the makeshift kitchen outside the doors of the museum, in the process producing soil so yet more food might be grown. Here too, with a joyous combination of humour and empathy we might listen to the humble labour of the worm munching its way through food scraps and shitting out the good soil.

More recently, back in Stockholm in the Spring of 2019 at an event hosted by Cecilia Åsberg and Marietta Radomska at the Posthumanities Hub at the Royal Institute of Technology (KTH) in Stockholm, Norie Neumark conveyed to the audience a message from the worms. In an experimental video work, Neumark and her collaborators attempt to offer a

translation of the underground murmuring of the worms at work in the soil, undertaking their otherwise invisible subterranean labour of composting (see Miranda n.d.). The creative video shows Neumark with headphones on, the headphones plugged into the soil. Her eyes are squeezed closed in serious concentration, as she listens and then strives to mouth the sounds of the worms. Her mouth screws up, and spittle leaks out as she makes the effort to convey their subterranean message. Humour, yes – this is funny, and we all laughed – but of a serious kind. The point here in Neumark's, as in Pentecost's, creative work, becomes one of acknowledging the dirty interconnections between dirt and soil, between worms and food waste, between seeds and life, all offering a challenge to what we deem valuable. It is the kind of work that the Swedish artist-researcher Janna Holmstedt is also dedicated to gently explaining, when she tells us that "Soils, commonly thought of as dirt, are in many instances a blind spot and a matter much taken for granted" and asks us how instead we might compose new human and more-than-human assemblies in relation to the dirt of the earth our biomass (Holmstedt n.d). The message conveyed by these representatives of the dirt is one that asks us to patiently wait, and to listen. To listen to the untranslatable story of the dirt and the worms. Here, dirt again returns us to something good: The good earth, the commons that we share.

Soil activism counters the pure equivalence of empty things rendered via advanced capitalism's financialisation of lifeworlds, the erasure of specificity, unpegged, unhinged, a deranged economics forgetful of the dirt. Maria Puig de la Bellacasa calls these our "soil times", by which she seeks to remind us of the precious life-giving resource that soil is, asking in the same breath how we might maintain an ecological care for the soil via "practical, ethical and affective ecologies" (2017: 170). Dirt might just be recategorised as soil, but only insofar as we are prepared to enter into reciprocal relations of care.

Chapter 6
Dirty Ditties

J ust a couple of years after Donna Haraway was celebrated on one of Claire Pentecost's *soil.erg* bills alongside Gregory Bateson, Vandana Shiva and other conceptual personae of the dirt, she published a book called *Staying with the Trouble: Making Kin in the Chthulucene* (2016). Haraway presents the theme of soil, or specifically humus, as a retort to the destruction of worlds signified under the new geological sign of the Anthropocene. Maria Puig de la Bella Casa, with whom I concluded the last chapter, was one of her students. The Anthropocene is a geological moniker much critiqued by feminist thinkers on account of the way in which it holds onto the grand signifier of the human, Anthropos. Haraway challenges human exceptionalism, leading the way into what has come to be called "the non-human turn" (Grusin 2015). Haraway, like Bloomer, is a fan of the dirty ditty, using her writing style to mess with convention, telling us stories of her ordinary encounters with creative practitioners and other thinkers and creatures. This is what she calls a "compostist practice" (2016, 150), a mulch of material imagining together. By way of the dirty ditty, I am on my way here to the conceptual persona of the theory slut, wary as I go of perhaps stepping too far. Making a dirty mark. First though, I want to gather Donna Haraway and Jennifer Bloomer together into one of Haraway's string bags, a simple container technology that allows us to carry ideas and things

along. Both of them take pleasure in speculative fab-
ulations, in the telling of stories and untidy parables.

What I propose these two material thinkers share is
a way of making concepts dirty. Making concepts dirty
requires putting them to use, accepting they will suffer
from the wear and tear of the many jobs that need get-
ting done. A dirty word is that which can offend those
who are upright and decorous. "I'll wash your mouth
out!" A child is threatened when using a lewd word.
Such a threat speaks to the myriad contaminations
that language threatens, the risk of offence, the risk of
straying from what is societally accepted as polite.

Haraway makes much of the dirt in her more
recent dirty ditties, playing on homophonic prox-
imities between humans and humus (not to be
mistaken for the delicious Middle Eastern spread).
Humans as humus have potential for the humusities,
she humorously asserts, as she presents her wilful
reorientation of the humanities (2016, 32). It's about
repairing ruined lands, reengaging worldly relations,
stirring up material semiotic thinking-feelings. Here,
dirt is hot. The death and decay of animal and plant
matter via the hot process of composting leads us all
the way to life-sustaining humus, what humans, as
far as Haraway is concerned, can aspire to become.
From her earlier work on cyborgs and situated
knowledges, through her discussion of cross-species
encounters to her most recent work on tentacular
thinking in an imaginary, speculative Chthulucene,

Haraway bumps colloquialisms and "knotty neolo-gisms" (Santos 2017) against high theory, bringing critical thinking down to earth.

Proliferating with neologisms and dirty word play, Bloomer's prose likewise takes pleasures in the dark secrets yielded by writing undertaken as a process of critical thinking. Open any chapter of Bloomer's *Architecture and the Text*, and you are likely to chance upon a wild ride that traverses vast conceptual and historical domains, as Bloomer introduces one concept-tool after the next, compos(t)ing as she goes something of a filthy and monstrous con-struction that provokes – that demands – new ways of thinking with architectures in formation. From Manfredo Tafuri to Walter Benjamin to Rosalind Krauss, to mention a few names relevant to her contemporary moment, with Bloomer you ricochet from thought to thought. Following this wayward passage, the act of reading co-constructs the archi-tecture of the text. The wayward movements, the leaps and lacunae, very much demonstrate the kind of work that dirty theory does. Always on the verge of tripping, falling and failing, getting the connection wrong, missing the point. Then recovering oneself, seeking a new path, another rhizomatic connection.

The whole of Bloomer's text, which is a construc-tion elaborate enough to rival any architectural edifice, is interrupted with a lexicon of concepts capitalised. From MINOR ARCHITECTURE to

HATCHERY to BABEL to CRYPT, Bloomer's con-
cept-tools continue to seethe and multiply and inter-
cede. She concludes her work on "(s)crypts" with her
own wayward heteroglossary of neologisms. That is
to say, she both argues and performs the way in which
words matter. Words are material constructions,
and wayward in their suggestions (Bloomer 1992,
11-12). Have we ever been so daring since Bloomer,
or have we merely allowed our theoretical peregri-
nations to sink into habit? Into what Douglas has
called the well-worn "habit-grooves" of our collective
sociocultural thinking (Douglas 1966, 5); including
what Bloomer describes as "The non-neutrality of
language and history (and architecture)" (1993, 3). As
unfaithful feminist daughters of Bloomer, we might
complain that the voices are gendered too dominantly
in the masculine, her key interlocutors being Piranesi
and Joyce, whom she madly reads across each other.
She offers her own excuses regarding the "giant
a-gents of history" (104), because ascriptions of sex
are not so straightforward.

Dirt is certainly a question of habits and habitat.
Rules dividing the clean and the unclean are based
a posteriori on habits that are established through
material trial and error (Douglas 1966, 55). To clean
discourse of its messiness and its open-endedness
becomes too much of an academic habit. To escape
from a discourse that is gendered in the value
systems of a dominant gender is also a challenge.

Meanwhile, should we be surprised that a number of the thinkers occupying the disciplinary domain of pedagogical research (the housekeeping of academia) are women who are unafraid to venture a dirty theory? To propose a dirty theory is to place oneself immediately at risk of contamination. On the one hand, dirty theory threatens to contaminate the researcher, making her methods not very respectable; on the other hand, this very contamination of thoughts and practices is inevitable and can be beneficial. Dirty theory can be a way to multiply positions and voices, to seek out and perform "the multiple vibrations of stories, experience and memories. Rather than reduce complicated and conflicting voices to analytical 'chunks' that can be interpreted free of context and circumstance" (Barker, Nye and Charteris 2017). This is the challenge that Lisa Mazzei and Alecia Jackson, cited in Barker et al., set themselves in their research on pedagogical practices, whereby they seek to find the means to deploy a poetic voice to explore diverse voices and positions, including of course the position of the researcher (Mazzei & Jackson 2012, 745).

Borrowing concept-tools from Deleuze and Guattari, Mazzei and Jackson speak of a process of 'plugging in' voices in their qualitative research. They explain: "We used voices of participants, our own voices, theoretical voices, voices of our teachers/mentors, voices of other scholars, and so on.

Rather than succumbing to the primacy of ONE voice in qualitative research (that of the participant), we plug in voices to produce something new: a constant, continuous process of making and unmaking" (2012, 747). To this we can add the urgent and ethical issue of citational practices, and the fruitfulness of breaking open conventional approaches to the research instrument called a 'literature review'. To hesitate, to purposively entertain an exercise in conscious-ness-raising in order to undertake a count of names in our bibliographical references, to be sure that a more diverse representation of thinkers is presented, and to let in voices from unexpected sources (and, as Mazzei and Jackson recommend, to mix them up and plug them into messy ameliorative assemblages): this is one of the challenges extended by a dirty the-ory. A dirty theory that appears to have travelled.

Mixed theories and messy practices, a feeling of being (matter) out of place in the academy, of being blundering, chaotic and unbridled, and yet for all this being joyous and unafraid! These are some of the indecorous practices-theories Sara Childers and her collaborators call "dirty theory". They describe their feminist practices as promiscuous and explain that: "'Promiscuity' is a racy, sexy, pejorative and even punitive term denoting 'bad' girls" (Childers, Rhee, Daza 2013, 508). A promiscuous feminist methodology is counter-signed by a theory slut who is unafraid to venture beyond what is deemed academically proper.

Chapter 7
Theory Slut

We are told from when we are young that little girls are made of all things sweet, while little boys, well ... "Snips and snails, and puppy dogs' tails. That's what little boys are made of. Sugar and spice and all things nice. That's what little girls are made of." No doubt a theory of the girl requires some reclaiming, for girls can be dirty, and not very nice, and why should they be deprived of these dubious traits? You dirty slut! Such a slur challenges the security of our self-identity. Dirt, we cannot avoid this, is deeply gendered. Ingrained, gendered dirt. Or, recycling Doreen Massey's proclamation concerning space, dirt is "gendered through and through" (Massey 1994, 186). You will have noticed already that my primary sources are indebted to women thinkers and practitioners, and those who get lumped with the reproductive labour. The invention of the conceptual persona of the theory slut is indebted to them, though admittedly the theory slut goes both ways, toward destructive and creative productions. To be dirty is to be crude, with the suggestion of inappropriate sexual innuendo. Given the post-Weinstein moment we are bearing witness to, disseminated via the social media movement #MeToo, this kind of dirty is one with which we ought to take appropriate care. Is it simply inappropriate, even improper, to introduce such a dubious character as the theory slut? Her representative function can help articulate

certain frustrations, demonstrating the difficulty of getting a more diverse cohort of voices to be heard. Who voices the dirty ditty, if not the theory slut? Smutty, dirty slut. Perhaps the theory slut can even offer some tips on citational practices, because she is nothing if not promiscuous in her looting of concepts and other appropriations. Her search for concept-tools takes her here and there, crossing boundaries, paying no heed to the warning signs at the limits of disciplinary domains.

Dirty theory, when critically applied, can become a devious form of creative resistance. Here is where the ambivalent figure of the theory slut enters the picture.

The theory slut is a figure who is connected with dirty theory, she is its slovenly housewife. Slut and slutty both refer to a woman who is slovenly – that is to say, a dirty woman unable to keep her household in good shape. Think of how Louise Bourgeois transformed her home into a great messy studio, a boiling pot of artistic possibility. The theory slut, where she practises a form of creative resistance, resists the decorum of the domestic environment. She refuses: I refuse to wash the clothes, to clean away the breakfast dishes! She swipes the whole mess into a pile and with great gusto attacks her next tactical, intellectual task. To be a theory slut, to let things go, to neglect the administrivia of housework, the economics of the home institution, can become

an expression of creative resistance. Why wash the dishes, make the bed, sweep the floor, when I can read more theory instead? Perhaps what we need is a theory of home economics. Probably the first port of call would be the economic geographers J.K. Gibson Graham (2006), if home economics is not to be the special school lesson reserved for useless and stupid girls but rather an alternative economics operating despite the globalised push toward financialization on every level of society. Home economics constituting its own radical push, an adventure in practising other modes of life.

A slut is slovenly. This means that she has no respect for neat boundaries, and is happy to miscategorise matter, putting it where she has been told it does not formally belong. But this is a great balancing act, domestic chores can be let go, but to what extent? Someone has to clean up eventually, to make room for future events and makings. The theory slut may be gunning for career advancement, or else the theory slut may be the one unafraid to get her hands dirty, who acknowledges that we must all get our hands a little dirty. Thought performs a material semiotics, a posthumanist new materialism that is situated because "material semiotics is always situated, someplace and not noplace, entangled and worldly" (Haraway 2016, 4).

Perhaps the theory slut takes up the housework again, but mobilises it as a weapon. When it comes

to housework, feminist philosopher Michèle Le Doeuff deliberates at length on the choice that is made between domestic duties and philosophizing; in fact, she is concerned with the working conditions of philosophical thinking in general for women (2007). The work of critical thinking requires reorientation if it is to liberate itself from orthodoxy. Here Le Doeuff explains that what she is after is a different kind of rationality, one that forgets its obsession with limits, aiming instead toward the "eccentric curves" of decentring operations, or what she calls a "migrant rationality which never wants to understand itself absolutely, although this does not mean that it should not try to understand itself as best as possible" (51). Her work, I should add, is exacting, attending to the dirty details of philosophical thinking where it is cut through with assumptions concerning women's capacity to philosophise.

Much like postcolonial, feminist and queer gestures of resistance, where slut begins as a slur, this pejorative can be turned around into a battle cry. I celebrate the slut that I am and I practise dirty theory because I have no trust in the making hygienic of thinking. I counter the purification of terms across great binary divides. Essentially, grubbily, dirty theory challenges boundaries, undertakes boundary crossings, and enables a black market, a dirty traffic in ideas. The three crucial boundary breakdowns, as Haraway has long ago argued in her Cyborg manifesto, include that

between the human and the animal, the organism and the machine, and the physical and the nonphysical (Haraway 1991). Boundaries and their articulation, in and out, clean and dirty, have a habit of proliferating. There is pleasure in breaking them down, and responsibility in building them up (Haraway 1991, 150). So, there is always work to be done in relation to the turf wars that boundaries imply.

Property, propriety, the proper name, the proper as such, as Catherine Ingraham has argued are related in their will to cleanliness and order. They are also concerns, she admits, that inevitably intersect with the gender question in architecture (1998, 89-90). We might ask: is untidiness dirty? Not quite. And yet, if you are untidy beyond a certain limit, we might call you slovenly. Lloyd Thomas explains that "Ingraham's work on the relation of architectural drawing to the ideal lines of geometry has been very influential. By asking what is improper to the discipline (sexuality, materiality, matter, irrationality, ambiguity, the female body etc.), Ingraham's work is particularly productive territory for a feminist inquiry" (2001, 59). We can mess with these modes of ordering by challenging decorum, by performing the dangerous role of women who make a fuss, by double-crossing the proper names who have left no sounding space for the minor voices and minoritarian architectures.

In passing, whilst meditating on the sacred and the profane, Douglas describes the story of Catherine

of Sienna, who drinks the pus of those whose wounds she tends as a sign of extreme empathy (1966, 7). Saint Catherine of Sienna performs a crossing over between the saintly and the sordid. Crossing over, where X marks the spot. The X is a material semiotic marker of specific interest to Bloomer, who in her discursive meandering notes that X stands for crossings over, including "the dirty, the bloody", including mixing sexes and genders (1993, 46). Opposites pass over into one another, contaminating, polluting, disordering taxonomies. X marks the process of troubling architecture. Bloomer wanders past Paul Klee's painting of an angel, his wings spread X-wise, a figure famously immortalised by Walter Benjamin in his oft-cited *Theses on the Philosophy of History* (Benjamin 1992). The angel, a saintly non-human creature, witnesses history as a pile of debris mounting ever higher. What some call progress, the angel witnesses as human trash; humanity inexorably laying waste to itself (Bloomer 1993: 46). In a more humorous anecdote, as she follows the crossings out of her X-marks-the-spot or the stain, Bloomer makes reference to Xanthippe "who poured a pot of piss on the head of her husband Socrates", no doubt polluting his discursive cogitations (1993, 45).

Let's remain with the stench of piss for a while longer. Isabelle Stengers and Vinciane Despret conclude their tinder-box-explosive book *Women Who Make a Fuss* with a scene of a woman pissing

herself and screaming out in horror at her own undoing. A piss protest? In her filth, and lack of demeanour, in her inelegant cry, she unwittingly enabled a future for generations of women who followed after her, who are not obliged to face the gallows. Stengers and Despret tell two stories, the first set in 1887. A woman who has been accused alongside her husband of killing her mother-in-law is led to the execution block screaming and yelling and dragging her feet. The executioner is so offended by the lack of decorum on the part of the condemned woman that he asks the President of the Republic of France to "grant clemency to women, these spoilers of his profession" (Stengers and Despret 2014, 166). To spoil something is to render it unclean. And women were granted clemency until Vichy, the authors explain. They add to this a further story of a woman in 1947 who when brought to the gallows screams and pisses herself in fear. She was the next to final woman to be executed. It would seem that women are not deemed fit to be executed, because they do not behave in an appropriately dignified manner. Rather than submit to their fate, these women rebel, they kick and scream, and finally they soil themselves. Such abject figures extend an improbably dirty moral tale. She, the despised one, to whom there appears to be little worth allocated, who, what's more, does not appear to have her wits about her, nonetheless, through her indecorous

performance, her polluting of the sacred rite of juridical sacrifice, through the disgust she arouses in those law makers gathered, makes it certain that for a great many years to follow no woman will be sacrificed at the gallows. In reading the tale that Stengers and Despret tell of these condemned women's resistance to death, a great effort must be made to stay with them, these seemingly unpalatable figures, but rest with these women who make a fuss is what we are asked to do. We must not avert our eyes in disgust. The moral of the story is a demand that women not submit with dignity to their situations, but make a fuss instead, speak out in order to challenge conditions on the ground where they are unendurable. This requires that one does not believe that the future is predetermined, or exhausted – instead, one must believe in the world and that one's protest might achieve a shift in a given state of affairs.

Then there is the character from Clarice Lispector's novel, *The Passion According to G. H.* (1988). Following the departure of her black maid who has recently quit, G.H. finds herself in the hollow shell of the maid's pristine room with the intention of tidying what she is surprised to discover is already clean. Pristine all but for a drawing on the wall (another boundary breach when it comes to decorum and decoration), and the discovery of a cockroach that she accidently crushes in her surprise. This otherwise inconsequential room, a maid's room that

the mistress of the house would otherwise avoid, splits open into a vast landscape, a desert, and time immemorial is unravelled in the intimate infinitude of an encounter between woman and cockroach (Lispector 2012, 54). Hélène Cixous introduces this narrative moment in her close and loving reading of Lispector: "A woman and a cockroach: these are the protagonists of the drama of Re-cognition called *The Passion According to G.H.* Shall I tell you?" (Cixous 1991, 134) she asks her reader, as though daring us. G.H. communicates in the first person, and frequently asks us to hold her hand as she journeys into the vast depths of the maid's small and sparse room as it unfurls into an immense existential and mystical terrain. Cixous speaks of the cockroach, but it is G.H. who in the same breath is described as "morsal of life, horrifying repugnant, admirable in its resistance to death" (134). An upper-middle-class woman who cannot even remember the name of her maid, a maid whom she has just realised always hated her, suffers a mystical crisis and as though in ritual performance places the oozing interior of a crushed, half-dead cockroach into her mouth. "The roach's matter which was its insides, the thick whitish and slow matter, was coming out as from a tube of toothpaste" (Lispector 2012, 57). Note in passing the image collapse of gross matter and teeth-cleaning product. This is a woman who, as is revealed, lived her own childhood in poverty, discovering a seething

community of bedbugs beneath her mattress (40). We are to understand that there is something saintly and sacred in the action of imbibing roach guts, or else some redemption is being sought. Cixous specifically describes a paradoxical "ascension toward the low" (1991, 135). G.H., who is assigned only these anonymous initials, brings the most disgusting matter into her body, challenging the limits of her disgust to the extreme, challenging the outlines of her own identity, coming into communion with a cockroach. "I'd looked at the living roach and was discovering inside it the identity of my deepest life" (Lispector 2012, 51-52). That G.H. is in the recently departed maid's room needs to be stressed here; class and race come into the gunky mix. I would like to hear what the maid has to say about this story.

As much as she is a *Putzfrau*, the theory slut is a little bit like a witch, inventing and practising rituals to break the stranglehold of norms where they have become oppressive. What are Ukeles' performances if not those of an artistic witch, bewitching foul substances and undervalued subjects and so magically bringing them to light? The theory slut's methods, as I have mentioned, are not very respectable, but they are methods, nonetheless. We sprinkle a little dirt during our magic rituals, to remember a lost homeland, to lament the passing of a loved one. Mary Douglas, Isabelle Stengers and Donna Haraway all hold a positive view on magic and ritual, implicitly

and explicitly locating its relationship to dirt (Douglas 1966, 22).

The ritual is a reminder of the diurnal passage of dirt. We can follow the dirt, which does not present a choice between growth or death, but a decision to slow down, to cry out against inequalities and social injustice (Stengers 2015, 23). How do we compose a future that is not barbaric, that is not driven by economic growth alone? To think, to produce concepts, to shake up habits, Stengers' hope, like Haraway's, is that we might reinvent new modes of production and cooperation that challenge the logics of growth and competition. Bloomer and Haraway share a love of reading Ursula Le Guin who in Bloomer is quoted as saying "No house worth living in has for its cornerstone the hunger of those who built it" (1993, 22). Stengers' hope, her trade in words, entertains an impure thought. What is the feel and look of an impure thought? Mark Savransky, reader of Stengers asserts that the magic of her philosophical wisdom is "like alchemy, it becomes an impure art – transformed by a speculative gesture that no longer confers on 'pure thought' the power to dictate the reasons from which judgments ought to be passed, or from which actions ought to be derived" (Savransky 2018, 6). Collapsing temporal registers, refusing to allow history to lie linear, Stengers draws our attention to the persistent smell of witches in our nostrils. This pungent olfactory affect stands as

a warning to the still precarious situation of women the world over, whose successes in achieving positions of influence and leadership may in one foul (sic) swoop be eradicated. Remember your dirty mothers, sisters, daughters and others.

Chapter 8
Dirty Drawings, Dirty Models

I want to get back to the dirt of Jennifer Bloomer's work. Bloomer has long been a figure of contagion for those attempting to think architecture otherwise, to come at it from the side, from behind and from underneath. She is a material semiotician *avant la lettre*, committed to the imbricated dialogue between the texture of the text and the messy material of dirty drawings and models. As Jane Rendell explains, "Through her dirty drawings and her incorporation of parts of the female anatomy – breasts, milk, fluids, blood, hatching, udders – into architecture, Bloomer generated a critique of the sterility of the architectural drawing process" (Rendell 2018). Rendell discusses Bloomer's use of dirty drawings and ditties, specifically the deployment of the double entendre with all its smuttiness. Let us celebrate our dirty forebears for showing us how to get our hands and mouths dirty.

The dirty drawing is neither representation, nor working drawing, but rather something composed after the fact, which pollutes both. Bloomer explains that the "dirty drawing addresses architectural representation by colliding the rendering with the working drawing (the sacred with the profane), while at the same time pointing to the fetishistic role of the image in architecture" (1992, 18). Remember, the fetish is that which attempts to replace some perceived lack. It covers up a hole. Perhaps it even fills in the poché. Comment is made on what Bloomer

observes as the rise of the architectural drawing as art commodity, and this too is what the dirty drawing challenges. She speaks at a moment when the Centre Pompidou and CCA are coming to recognise architecture as collectible. Dirty drawings, like dirty money, enter into circulation. Katie Lloyd Thomas explains that Bloomer's dirty drawings delve into the improper domains of materiality and tactility, explored specifically through the use of organic inks on rough paper (Lloyd Thomas 2001, 66). Between constructed installation and dirty drawing there is room for interpretation and inexactitude, for interplay.

The result of her material semiotic project *Tabbles of Bower* is a grotesquerie. But that's alright, because as Bloomer herself has pointed out in her "(s)crypts", the *grotto-esque* speaks of the dirt of the underground (1993, 11), a *grotesquerie* is a 'base' object (1993, 23). What is also improper is the narrative meander that cuts its transversal route through the essay. We open onto a bedroom scene, Bloomer's own boudoir, a bassinette awaiting the birth of her child. Handed down furniture is introduced, the ordinariness of their first appearance yielding layers and layers of family lore. To allow the personal to infiltrate the academic is always a high-risk venture, and apt to go wrong. Bloomer is rare among those who can pull it off. The challenge is how best to avoid the merely personal project, the 'artistic' home renovation, for instance, with forced quirks. The *Tabbles of Bower* is

not that, though it would be possible to imagine the perplexed reception that the installation must have received at the time (Bloomer 1992). The *Tabbles of Bower* discussion extends from the bedroom to a reflection on the history of the colonisation of the Americas and the role that the exploitations of slavery, displacements and the murder of human communities played there. It looks to the untold stories of the origin of such cities as Chicago, first settled, as Bloomer informs us not by white forefathers, but by Jean-Baptiste Pointe DuSable, a black man from Jamaica, who married a native American woman after his arrival (1992, 13). The task of dirty theory is to rewrite the story, to reclaim it. Bloomer brings to light the relationships that can be discussed concerning dirt and colonisation. She achieves this through her material textural constructions. *Colon*, French for column, and for order, lending itself to colonisation (1993, 13). Bloomer knows her shit, though she doesn't mention that the colon is a passage through which excrement makes its way into the world, at least not at this theoretical juncture. The dirty work that Bloomer undertakes aims to trouble the dominant narrative, interfere with the majoritarian take in architecture by raising the minoritarian stakes. In fact, it is Bloomer, and none other, who first introduces Deleuze and Guattari's concept of the minor to architecture – specifically revising a minor literature as a minor architecture – thereby

conjoining their philosophical work with a feminist project in architecture from the get go (Bloomer 1993, 173; Burns 2012).

"Hot Mama Pink" canvas and cord, lace, a fake fingernail, glass beads, oyster shells, fishing lures (homemade), cowhide, pink lycra, mattress batting, beeswax, are included on the list of materials deployed by Bloomer in her *Tabbles of Bower* (1992). Rendell draws attention to the architect Sarah Wigglesworth's the Straw Bale House in something of the same vein, calling out the troubling of building regulations that the specification of the straw bale as building material entailed (Rendell 2018). What effects might we produce – social, technical and environmental – when we introduce materials that are not supposed to belong? Bloomer is messing with the logics of specifications and appropriate construction materials: "An other architecture is the architecture of abjection (the thrown away)" (1992, 27). The abject being that which is expelled, refused. Refuse. Quite an 'other' architecture from Gissen's rather more restrained subnatural environments of architecture. In the end, the whole construction of the *Tabbles of Bower* is a sweet dedication to Bloomer's recently born daughter.

Bloomer's work can be located in a wonderful feminist genealogy that includes the commentary of Jane Rendell, Karen Burns and Katie Lloyd Thomas; the wild feminist material performances of Julieanna

Preston (2014); and the queer and intense inventiveness of Brady Burroughs' "architectural flirtations" (2016). The work travels forward productively staining the projective thinking of the discipline of architecture, messing with its will to form, and its convenient forgetfulness concerning the mess of materials.

Murmurs of the promises of dirt in relation to architecture have been heard issuing from the lowlands too, where the sea threatens to engulf all and only the dykes hold settlements in place. Reading the Dutch architectural theorist Roemer van Toorn, the role of the politics embedded in what he calls "dirty details" and "dirty regionalism" come to the fore exactly where there is a shortage of landed dirt. A great deal is at stake in the dirty detail, and architecture is seen to carry a great load. The dirty detail, like Japanese "Wabi-sabi" (here with a slight whiff of cultural appropriation) must satisfy three realities, van Toorn explains: that nothing is eternal, nothing is complete and nothing is perfect (2001). The attribute of dirtiness resides in the counter-qualities of transience, incompletion and imperfection. Urban scenes support agglomerating materials, the proliferation of the 'and', and what van Toorn calls the Society of the And, which gathers the dirtiness of everything. He looks for progress is the dirtiness of reality, rather than in its taming. Surely great risks abound here? Has dirt been unleashed too wildly, become too widely accepted? The essay on the dirty

detail comes first, and it is followed some years later by van Toorn's essay on dirty regionalism as a retort to critical regionalism. So, dirty here offers another form of critique.

Van Toorn introduces the dirty detail as a way of delving into the risks of a consensus-driven liberal society hiding behind the agreeable veneer of a "fresh conservatism", all fashion and style, and no dirty substance. Dirty details for van Toorn – and his interest is centred on the potential of design to make a difference – use alienation, absurdity and antagonism to open up a constellation of points of view on difference. Dirty details speak to differentiation as process. He argues that "Dirty Detailing is a strategy of a multitude of resistance" (2001). What I read here is a resistance to the norm, a resistance to complacency and a resistance to comforts that keep too many on the outside in situations of vulnerable discomfort. The dirty detail, and his concept of dirty regionalism, inspired by the agonism of Chantal Mouffe, goes in search of a democracy that acknowledges the challenge of the difficult dialogue required. What Haraway would call staying with the trouble, not looking for quick solutions. A brief search shows that neither Haraway nor Bloomer show up as protagonists for van Toorn. They are still way too dirty.

In the pedagogical context, in collaboration with colleagues Sepideh Karami, Adrià Carbonell

Rabassa and Hannes Frykholm, in a studio that we believe is felicitously named, *Infrastructural Love*, we have taken on the dirty drawing and explored it via the exercise of 'the dirty model'. The dirty model mixes material and concept, playing a material-se-miotic game. Refusing the will to representation and form, it employs a non-representative approach, working on the level of affect aroused. Mostly discomfort and disgust. Dirty affects are ordinary affects. The central instruction offered was: make it as disgusting as possible. Most failed, and many avoided the task entirely as too distasteful, as lack-ing gravitas. Perhaps these are simply concept mod-els, but if that is the case, then concepts themselves must be re-conceived not as pure but dirty too.

Let's take Marie Le Rouzic's dirty model. She learns from the gleaning methodologies depicted in Agnés Varda's documentary film *The Gleaners and I* (2000) where leftovers from the harvest are collected, and in urban milieus food stuffs discarded after the street markets have closed are retrieved by urban gleaners (see Frichot 2018). Le Rouzic collects her debris from a post-industrial site in Veddesta, north of central Stockholm, Sweden. Trash and site refuse are mashed together into a solid block with bits stick-ing out. The future of this site at Veddesta is already decided, it will be a full clean-up job: multi-residential medium-rise apartment blocks, a hospital, a new rail line running through and connecting to an

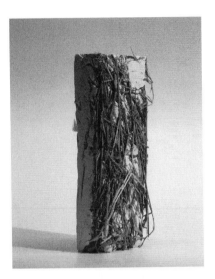

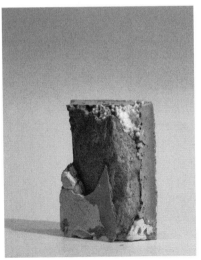

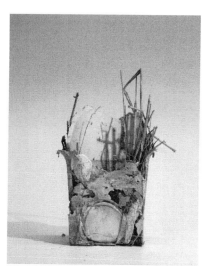

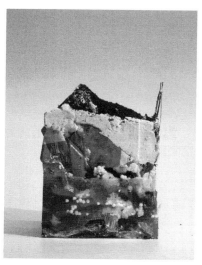

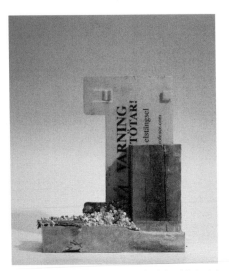

Fig. 9 Marie Le Rouzic, Dirty Models. *Materials gleaned from the former industrial site of Veddesta. Critical Studies in Architecture, KTH Stockholm, 2019. Photographs by Marie Le Rouzic.*

existing commuter line. The development of Veddesta forms part of the response to the pressure to produce housing for a growing population in a city where real estate is exorbitant, and the rental sector near impossible to access, especially for those arriving from the outside or elsewhere (Frichot and Runting 2019).

The dirty model is compelling, as fascinating as the plug of mixed trash clogging the sewer on Cold Spring Lane described by Jane Bennett (2010). The task composed becomes something more than dirt, a kind of aesthetic treasure. But at this moment it fails. Yet failure is part success, a part-object and

how it circulates reminds us of dirty pasts, unexpected encounters and abrupt collisions (Cheatle 2017; Bloomer 1993, 71, 105). We must make the best of what happens to us when we get down with the dirt. To feel the dirt of the world can transform into a creative and a speculative gesture, even as simple as a mud map or the quick esquisse of a dirty model.

Chapter 9
Dirt and
Differentiation

We could – and this would certainly be allowed by a disreputable dirty theory that does not hesitate to leap across disciplinary boundaries – bring Gilles Deleuze's philosophy of difference into the orbit of Mary Douglas's discussion of dirt as that which is utterly undifferentiated, as that which threatens us with its formlessness. Deleuze's philosophy of difference leads the way to an ethics of difference, via Whiteheadian prehensions of environmental surrounds. To prehend is to grasp and to grope, to feel our way *with* the dirt. We are ever at risk of becoming too avaricious in our grasping. Projecting our efforts in one direction, we attempt to distinguish ourselves, to rarefy and purify our endeavours; moving in the other direction, we become indiscernible, swooning into a slow dissolve. Here we see that the dirty model, the dirty detail, is always doomed to a kind of failure at the moment of resolution, when form is begat from the mess. What must not be overlooked are the arts of noticing and the relations procured on the way. Cycles of dirt, erupting here and there, differentiated, and then, with time, inexorably losing differentiation: We are as much a part of these cycles as our projects.

Much like that dirt ball Earth following its diurnal path, dirt moves through unending cycles.

In this final stage of total disintegration, dirt is utterly undifferentiated. Thus a cycle has been

completed. Dirt was created by the differenti-
ating activity of mind, it was a by-product of the
creation of order. So it started from a state of
non-differentiation; all through the process of
differentiating its role was to threaten the dis-
tinctions made; finally it returns to its true indis-
criminable character. Formlessness is therefore
an apt symbol of beginning and of growth as it is
of decay. (Douglas 1966, 161-162)

Processes of differentiation and indifferentiation
show up here as powerful creative forces. Difference,
for Deleuze, moves in material-semiotic ways,
producing disjunctive syntheses between the *dif-
ferenciation* of the actual and the *differentiation* of
the virtual (1994). Where the virtual animates all that
is with potentiality – irrespective of whether or not
this potentiality is satisfied – processes of actualis-
ation resolve the virtual, albeit often fleetingly, into
something material, the actual. A simple distinction
Deleuze offers here is between the mathematical
function of *differentiation* (with a *t*) and the biological
fits and starts of *differenciation* (with a *c*) (xvi, 279),
heading by way of the disjunctive and conjunctive play
of these concepts toward a "vegetal mode of thought"
(xvi), an (indi)-differen*t*/ciation liberated from a
dominant status quo. The t/c is an inexhaustible
engine producing new things and thinkables. At the
same time, the thought of difference is independent

of human exceptionalism, yet that which upon which human creatures depend where we understand human creatures as complex subjectivities in formation embedded in ever transforming environment-worlds: "one does not think without becoming something else, something that does not think – an animal, a molecule, a particle – and that comes back to thought and revives it" (Deleuze & Guattari 1994, 42). From processes of different/ciation, and holding on to the dynamic interchange of the t/c, all possible forms of life and modes of thought unfurl. Without such processes, no life – nothing – is possible, this at least is what Douglas and Deleuze share in their meditations on indifferentiation and differentiation.

Karin Reisinger writes of how "architectures grow, regress and vanish in relation to the environment on which architectures depend" (2018, 210), which is an apt description of processes of (indi)different/ciation. There is the dirty resilience of difference and repetition at work in our work with the dirt. Through her "dirty narratives" (that's what she calls them), Reisinger is dedicated to the emergent possibilities of the debris of abandoned architectures. She too follows the differentiating cycles of dirt. Offering a close-up account of the cohabitation of war-torn and ruinous buildings with animals in search of safe haven – a family of pigs, a cow, even a lion perched on a roof (a real live one) – Reisinger introduces dirty resilience as that which allows architectures

to endure "through getting dirty and serving nonhumans as immediate environments" (Reisinger 2018, 208). Reisinger tells us what we know but try to hide from: that as much as architecture orders a world, it is apt to fall into disorder and decay. Architecture differentiates itself from the ground, then returns again, becoming imperceptible, undifferentiated. As Douglas argues, we can follow this cycle of dirt and understand its inherent creative surge.

> In its last phase then, dirt shows itself as an apt symbol of creative formlessness. But it is from its first phase that it derives its force. The danger which is risked by boundary transgression is power. Those vulnerable margins and those attacking forces which threaten to destroy good order represent the powers inhering in the cosmos. Ritual which can harness these for good is harnessing power indeed. (Douglas 1966, 162)

Curiously, we could be reading the opening passages of Deleuze and Guattari's *What is Philosophy?* where they lay out their plane of immanence and speak of the chaosmosis from which concepts emerge, as though the creation of concepts were an act of cutting a transversal section through chaos, which is never inert or stationary (1994, 42). Dirt is not same-difference, it is processual difference through and through. Better still, I could conclude

this brief chapter on dirt and difference with a quote from the black lesbian feminist Audre Lorde, who writes "Difference is that raw connection from which our personal power is forged" (2007, 112). It becomes clear that difference is not stablised, not completely set in place, but out of place, full of displacements and sideways movements and slippages. An ethics of difference and processes of differenc/tiation speak of the intersectional struggle of the minutiae of everyday spatial existence.

Chapter 10
Dirt Ball

This story is for my dirty boys, who pride themselves on the evidence of the dirty world that they carry beneath their animal fingernails. It is a story about a girl who has lost her dirt, who has lost the unclean joys of a world. In fact, she, and the three generations before her, have never experienced the unclean earth. She belongs to the fifth generation, while the first generation are those that sought their departure from the dirt ball in a container technology, a spacecraft, an impenetrable, hermetically sealed and purified life-bubble.

Better than Jean Luc Nancy's etymological dance with dirty words, I turn your attention to the mediated distant visions of the short tale *Paradises Lost* where Ursula Le Guin introduces our lost home, the 'dirt ball' (2016). This is a spatial story describing an impossible search for another home following the Planet Earth's devastation. A child, 5-Liu Hsing is depicted trying to imagine the dirt ball she has never experienced, growing up instead in a hermetically sealed vessel with 4000 others, cast into outer space in search of another dirt ball that may accommodate them. The year is 141. Each day she takes her lessons, and tries to imagine: Where have we come from, where are we going?

Le Guin's *Paradises Lost* concludes with a quicker than expected arrival at the new Earth, dirt ball 2. Once some "settlers" have landed, a series of vio-

lent, sudden deaths are witnessed in quick succession, brought about by a basic lack of understanding of what it means to inhabit a non-controlled environment. A young baby dies of sunburn, a woman discovers an extreme and uncontrollable fear of insects, adults and children succumb to the elements. What are we to understand, nonetheless, of this abrupt arrival, one generation sooner than expected, aboard the massive spaceship called *Discovery*? The humans have now become settlers of the new Earth, and they are strangely inept, attempting comically to plug electrical instruments into tree trunks, but finding no sockets. As the human creatures' dependence on technologies deepen, so their 'neotenic' insufficiencies become more pronounced (Sloterdijk 2011); as Peter Sloterdijk opines, ejected prematurely from the mother's womb the human animal is more vulnerable to the environment than other animals. What will the aftermath of their colonisation be? Will these already troubled though bucolic scenes descend into something darker?

To imagine a possible escape from dirt of our own making is a dangerous exercise. As a parable of our profound relationship with dirt, le Guin's speculative fabulation nevertheless cautiously holds out hope that we may act in advance of such escapist measures. Let's place a Deleuzian cry on repeat here: We've got to believe in this world! This becomes our most difficult task.

Chapter 11
Dirt and
Decolonisation

People everywhere, human subjects classified as foreigners, migrants, ethnic others, minorities, women and children or the enslaved, are often assigned the derogatory denomination of dirt or dirty. They are cast out, rejected, treated as subjects of dangerous contagion. The other is assigned that place outside as foreign material, but this displacement is procured in order to fortify that which is the same, through regimes of slavery, indentured labour, a silent infrastructure of exhausted, racialised bodies cleaning, ever cleaning, forever cleaning. If the promise of difference emerges from processes of (indi)-different/ciation, then the same is that which must be addled, critically challenged and called out for its cruelty.

There exists a history of philosophy that has deployed concepts for the purposes of colonisation, establishing a divide that still exists today, Stengers asserts (Stengers 2012). Latour and Haraway call the outcome of this process the "Great Divide". On one side, sit those who believe they have claimed the right to study and categorise others, and on the other side those muted others, those marked bodies who will be placed under investigation, or else rendered invisible. Stengers cites Eduardo Viveiros de Castro who describes the imperative to undertake a "decolonisation of thought" (Stengers 2012), which is a reclaiming of other possibilities for philosophy. This is a matter of resisting the colonising power

that seeks to judge, or even simply to tolerate that which is deemed less civilised and knowledge practices and belief systems that are judged to be questionable. Furthermore, we must think according to the milieu, and not seek to separate out of the milieu those things, animate-inanimate, material-immaterial, which depend upon it. To reclaim the milieu "begins with recognizing the infective power of the milieu" as Stengers puts it (2012); to recover the milieu means to get over the 'Great Divide', the bipolar logic that insists on us and them, same and other. To be done with the judgement of others and instead to work alongside and with them/us seems an apt imperative for a dirty theory.

When Françoise Vergès places gender, waste and decolonisation together into one dirty bundle, she does so to draw attention to the existential exhaustion that plagues the daily labours of maintenance delegated to thousands of black and brown women, migrants and refugees the world over. The exhausted bodies of women of colour serve a "racial capitalism" that rests upon an "economy of exhaustion" (2019). Her argument can be seen to intersect with Nancy Fraser's discussion of the crisis of care, where Vergès states that without this multiplicity of exhausted bodies "neoliberal and patriarchal capitalism would not function" (2019). Vergès composes a complex image of a live infrastructure of racialized women, who are witnessed to circulate through

the contemporary city, passing in and out, between spaces of publicity and privacy, invisibly, thanklessly propping up urban life as we know it. Defining waste, Vergès draws attention to how we can lament the laying waste of the world via slavery and processes of colonisation: "Instead of answering human needs, slavery, colonialism, and capitalism have constructed desires for things that we do not need while obstructing access to what we do need (clean water, clean air, clean food, clean cities)" (2019). She then goes on to outline the millions of tons of global waste we collectively produce each day. Conceptual waste and intellectual time wasted might be added to this inventory.

A quick and dirty hunt for occasions where dirty theory has proved fruitful reveals many efforts toward decolonisation directed at shifting the dominance of white Western voices and the hegemony of the Global North. Challenging Western academic epistemic and intellectual traditions Rauna Kuokkanen introduces dirty theory as a project of decolonisation: "Through dirty theory we ensure that voice is not taken as representative and totalising/universalising. Voice work that homogenises groups of people can be seen as 'epistemic ignorance' as the academic practices and discourses that enable the continued exclusion of other than dominant Western epistemic and intellectual traditions" (Kuokkanen 2008, 60). These are extremely challenging habits

to break, as we too often prefer to maintain the comforts of our intellectual habitats. Australian sociologist Raewyn Connell likewise challenges the predominance of the Global North as the source of adequate knowledge, extending as a counter-project a "Southern theory" likewise deploying what she calls "dirty theory" as a localised response to pressing questions (Connell 2007, 207). For her, dirty theory aims to avoid classification from the outside or from a distance, instead attending to the con-creteness of a situation. An alignment can be figured between her project and Haraway's enduring work on situated knowledges (Haraway 1988). The aim for Connell's version of dirty theory is to "multiply the local sources of our thinking" (2007, 207), which I take to mean opening up to a diversity of points of view and paying attention to what each apprehends, and what each has to say. The aim is to undertake a reori-entation of the hegemonies of theory in the Global North, and to engage instead with the postcolonial, decolonising potentialities of the Global South.

Feminist political ecologists Wendy Harcourt, Sacha Knox and Tara Tabassi ask: "What are our different relationships with land and soil and that deemed dirty and abject? What are the connections between those living on ancestral lands, struggling for sovereignty and stewardship-based revolutions and those who are products of settler colonialism, globalisation, migration, forced displacement,

mixed heritage, state or interpersonal violence?"
(Harcourt et al. 2015, 300). They ask, finally, "how can
we embody dirty resilience?" by which they mean
a reciprocal alliance between our bodies and the
earth: being fed by the earth, and in turn becoming
humus as we ourselves feed the earth. They cite the
activist Vandana Shiva to elaborate on what a dirty
resilience might contribute to decolonial struggles,
and what becomes evident is that this is a question
for human subjects as well as for animal and vegetal
subjects.

This brief chapter subsumed dirty theory in an
intellectual space where many important thinkers
are working. This is a space that scholars must be
wary of colonising, being prepared instead to listen,
to learn and to acknowledge the invaluable contri-
butions of those whose voices are always at risk of
being marginalised.

Conclusion –
Creative Dirt

This little book has addressed some of the sordid possibilities of dirty theory, lodging itself as unwanted matter under the banner of the diffuse disciplinary domain of architectural theory and venturing into adjacent fields where art and architecture get messed together contagiously. I have introduced the theory slut as uneasy conceptual persona with her dirty ditties and labours of critical care. I have offered glimpses of creative projects that engage the perpetual work that a dirty theory might accompany. The chapters extend a series of brief, scrappy, and very open invitations to the reader to think with the dirt.

Getting down and dirty, there is dirt that is good for you, and dirt that is bad for you; there is dirt that can grind you down, and dirt that can build up your immune system and make you stronger. Gut bacteria, for instance (Haraway 2007). Sometimes the hygienic regime of clean lines and surfaces presents the worst direction to take, and in terms of attempts at purification, the vulnerable of the world are those most likely to suffer. Dirty theory draws attention to the intersections of gender, race and class with respect to all the complex socio-spatial, geopolitical and lively material relations of the behemoth: architecture.

This is not a story of the good, the bad and the ugly (Cousins 1994; 1995), and certainly not one of good and evil. Dirty theory acknowledges the

ambivalence of theory generally, and that it can be deployed toward all manner of ends. Theory can produce effects that were never intended, much as the best intentions of the architect, and the architectural theorist, can go easily astray. Intentions, what's more, tend to be detached from the diverse forms of reception that are practised in relation to architectural theory. Anyone into the texture of textuality knows that once a text is released to the world, it is anyone's. Like poison and toxic insecticides, dirty theory makes clear warning labels at once necessary and highly ineffectual.

Returning briefly to the island of pure reason, surrounded by the mists of illusion, what we apprehend once the mist clears is a mounting pile of debris. Former landfill sites like Battery Park and Fresh Kills are today celebrated, having been reclaimed by way of the ethico-aesthetic works of artists such as Mary Miss, Agnes Denes and Mierle Ukeles. The thought-image of the trash pile that mounts higher and higher is an image that travels, it can be found before Walter Benjamin's figure of the awestruck angel, where the mountain of waste has been named "progress" (Benjamin 1992). The island of pure reason turns out to be composed of trash and yet concepts and things can be salvaged from this midden for future use. Cutting an archaeological cross-section through the island of trash reveals histories and former styles of life. We learn by reading the trash.

In *Geostories: Another Architecture for the Environment* (2018), Rania Ghosn and El Hadi Jazairy take on the waste dump of architectural history and make it projective. In their speculative project *Trash Peaks*, they look to the significance of waste in the daily life of the inhabitants of Seoul, Korea. To compose their drawings, which function as critical architectural gestures rather than documents anticipating future construction, they sample from a history of architectural projects, such as the Kunsthaus Graz by Peter Cook and Colin Fournier, Lequeu's Temple de la Terre and BEL Architect's Watchtower. A cross-section reveals surprising connections and even constructs unexpected proximities. Historical periods collapse upon each other in what might appear irrational ways. Meanwhile in the background of Ghosn and Jazairy's design thinking looms anxieties about environments. They argue that such anxieties extend to issues of representation: We must strive harder to imagine, visualise, model and tell stories of other relations we might forge with our rapidly transforming environment-worlds, "nurturing new habits of seeing...projecting alternative forms of organizing life" (Ghosn Jazairy 2018, 13). The book's epigraph cites Ursula le Guin, urging us to accept the role of dark fantasies and the dangers of too much light: read *clarity*.

We need a great and dirty critical infrastructure to manage what confronts us today as the Earth

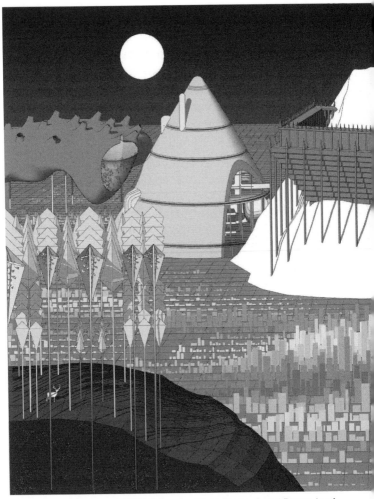

Fig. 10 Rania Ghosn and El Hadi Jazairy, *Trash Peaks*. Seoul Biennale of Architecture and Urbanism, 2017.

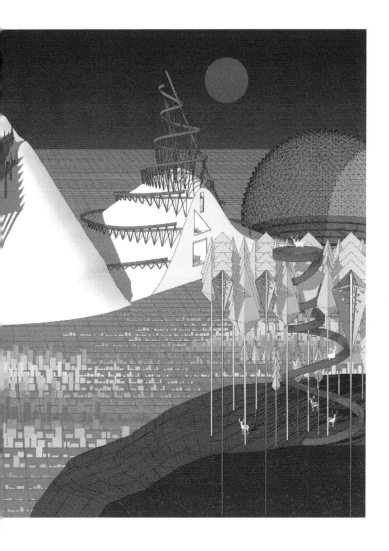

155

suffers. Underground facilities to dispose of both material as well as conceptual effluents. Dirty theory may be ambivalent, but it does not demand that we go in search of an unsoiled and pure theory. No such thing exists. Dirty theory is where it is at, and yet the greatest of vigilant care must be paid because its application will have implications. There are ethical limits to how far a theorist can read against the grain of a dominant image of thought.

What is profound, what is worth holding onto, is that while "Dirt offends against order. Eliminating it is not a negative movement, but a positive effort to organise the environment" (Douglas 1966, 2). Douglas, whether intentionally or not, makes dirt a primary question for spatial practitioners, by explaining that: "In chasing dirt, in papering, decorating, tidying we are not governed by anxiety to escape disease, but are positively re-ordering our environment, making it conform to an idea" (2). It is a creative movement that seeks order, or more radically still, a new order, other ways of organising the environment. Dirt or pollution operate instrumentally and symbolically, and a close reading of dirt reveals hierarchies and symmetries, and patterns of organising a society or, at a smaller scale, a disciplinary domain such as art or architecture. To impose order on a world, locally and globally, we must work with the worldly as that which is intimately dirtied. This also means that we should remain critically wary of reordering the environment

according to a bad idea. In staying with the trouble, in troubling architecture, what I want to stay with are the creative possibilities opened up by dirty theory, and orientations that direct us toward the dirt.

Some of this has meant reflecting on aesthetic ancestors, who we might still learn from. Anachronisms, as I've stressed in opening, can provide some useful dirt. In the 1990s, at much the same time that Bloomer was composing her dirty ditties, a number of collections were published that addressed both directly and obliquely the lack of representation of women in architecture, even seeking out the aesthetic strategies and tactics of an *écriture feminine* for architecture (Hughes 1996; Agrest, Conway and Weisman 1996; Ruedi, Wigglesworth and McCorquodale 1996, and so many others!). In their introduction to *Architecture and Feminism*, Elizabeth Danze and Debra Coleman argue that "many women seeking acceptance in the field of architecture sought to disassociate themselves from talk of gender difference in order to escape 'being tarred by the brush of female Otherness, of being contaminated by things female.' (For example, the notion 'woman architect,' widely disdained for presupposing an odious distinction between architects and women architects, is seen by many as an unavoidable outgrowth of gender consciousness)" (1996). To be tarred by the brush, to be tarred and feathered, is to be tainted and

coloured, to be humiliated and pointed out. An intersectional mix of gender, class and race are at work in this violent act. Even today there persists the risk of being sidelined for being that woman who makes a fuss. In response to a growing sense of social, political and environmental urgency, moving from otherness into a field of relationality, exploring a shift to sexed difference amidst a relational ecology, feminisms in architecture today express a diversity of positions, and there is a hopeful, even joyful resurgence of engagements across this domain (Frichot, Gabrielsson, Runting 2017; Brown Harriss, Morrow, Soane 2016; Schalk, Kristiansson, Mazé, again, just to mention a few from the ground swell of work!).

In this mix, dirty theory requires that we pause, that we slow down, in order to ask: What are the outlines of a creative ecology of practice in which we might work alongside each other? What are our relevant requirements and obligations? Criticality from within (the dirt) and immanent critique are both dirtied because the pure and objective standpoint, the 'God trick', has been challenged, but its insistence requires the tireless retort of the dirty theorist. Dirty theory fights, it weaponises its concept-tools, and in developing such tools its disrespectable methods are ever apt to be coopted or else sidelined and dismissed.

Misinformation is the white noise of our era, as environments and species numbers collapse as quickly as our will to believe in a world. The current

world order has come to be called post-factual, as it would appear that facts no longer hold weight. No doubt this was the kind of thing Latour worried over when he realised some of the implications of placing matters of fact to the side in favour of matters of concern (2004). What might constitute a fake fact in architecture? "Fake" here is composed by omissions and erasures, the forgetting of creative actors other than men when the story of the history of architecture, for instance, is told. The story passed down gets passed down as a gloss, a white out. In more ways than one. And yet, matters of concern seem to have aroused our collective attention, as a flurry of recent books dedicated to architecture and gender, and a sea of pink pussy hats at Women's Marches in 2017, 2018 and 2019, have vocally, visually and humourously demonstrated. "The master's tools will never dismantle the master's house", Bloomer cites the oft-cited Audre Lorde (1992, 25: Lorde 2007), who gives us pause, for where shall we find the tools? We must invent them, but we must learn from each other to do so. Taking our differences, making them strengths. Dirty theory collaborates in this cause, which means it must watch out for the persistence of white feminist privilege too.

With friends, and family, colleagues and messmates, I have talked about the necessity of cleaning up my text. They have responded, "but it should be dirty, surely?!" When a text is submitted, and worked

over, we speak of clean copy. You might wonder about the choices made here, from thinkers to style, from paper quality to typesetting. "Where is the dirt?" you might ask. I would answer that style and dirt are not polar opposites, but unholy collaborators. Even though I venture into the various kind of muck that dirt is, the thinking herein must nonetheless have consistency as it outlines a dirty theory. Dirt has its own consistency: it *is* matter, whether rendered in concepts or as unmentionable gunk, via material or semiotic display, and it must at least minimally hold together, even if, like Pentecost's soil bullion, it crumbles a little and smudges its surfaces of display. Even if it begins to smell a little.

Part of what has motivated this foray into the dirt, and this contribution to the project of dirty theory, lies in my own frustrations with my disciplinary location at the interstices of architecture and philosophy, where something of a misshapen hybrid of thinking-doing can be found. If the dirty work I attempt becomes dirt thrown in the eyes of both domains to obscure a clarity of vision and purpose, then this presumed clarity and shared vision is what I seek to challenge. The dream of interdisciplinarity, however, overlooks the challenging domestic chores of subscribing sufficiently to disciplinary order. "Our idea of dirt", Douglas explains early on in her book, "is compounded of two things, care for hygiene and respect for conventions" (1966, 7). What is a proper

manner of philosophising? What are appropriate questions for the field of architecture? What are the implications of respecting the conventions of architecture and philosophy both without asking further questions? As for what pertains to architecture, what are the risks of muddying the serious work of constructing the fundaments of shelter with the ephemera of installations and performances, and art? Shouldn't we be concerned that this is the direction too often taken by women practitioners?

While the act of dirty theory is signed – by the theory slut herself, no less – dirty theory does not belong to anyone in particular. It remains an intellectual commons to be shared. And as for dirt, dirt is suspect, and every writer-thinker who thinks with it risks contamination. I'll reiterate: The dirt of the world is what dirty theory follows, developing an ethical expertise on the way. We all have our dirty habits, and we must reflect on those habits that are destructive of worlds, seeking instead habits that produce habitats more amenable to life. Neither dirt, nor dirty theory, are respectable or decorous, but what they invite is hands-on experimentation.

Acknowledgements

The stain on the futon mattress, near 15 years old. Hair clogging the shower drain, making me gag. Cigarette butts on German streets, and damp little used-up packets of smelly *snus* on Swedish streets. Nuremberg, the stink of piss along the city walls when I walk the dog. Stockholm, stepping out for a morning coffee, vomit on the sidewalk from Saturday evening revelries. A scene in a TV series where a character awakens to discover he has soiled himself during the night, besmirching the crisp white sheets with shit. The glance from the cleaning lady in the hallway later as she takes away the filthy bed linen. My own personal geographies of trash. These are all ordinary encounters with dirt, non-threatening, arousing only vague unease. There are many more reflections, more or less disturbing, such as these that friends, colleagues, and family have been happy to share with me. Sepideh Karami, Adrià Carbonell Rabassa, Hannes Frykholm and Olga Tengvall too, with whom I enjoy pedagogical adventures, I thank you all for brainstorming with me. Helen Runting, the sharpest mind I know, who spent time cleaning the dirty text (I realise there is a whiff of paradox in such a process), thank you. I should hasten to add that any errors remaining in this foray into dirt and

my contribution to the collective endeavours of dirty theory are my own dirt. I thank Brett Ascarelli, who regaled me stories of the contents of a small human being's diapers, as I'd almost forgotten what it was like to engage in that daily soil. Karin Reisinger, who offered invaluable feedback on the manuscript, many, many thanks. Yara Feghali, with whom I had the pleasure of working on architectural theory at SAC Frankfurt, I am grateful for your encouraging comments and taking time to read the manuscript. I'm thankful to Elke Krasny for conversations we have shared about critical care, and also Heidi Svenningsen Kajita who organized an intimate seminar with colleagues on the ethics of care. I am grateful to those creative practitioners who allowed me permission to discuss and reproduce images of their work: Mierle Laderman Ukeles, Julieanna Preston, Zuzana Kovar, Małgorzata Markiewicz, Anna Ingebrigtsen, Malin Bergman, Marie Le Rouzic, Rania Ghosn and El Hadi Jazairy. I also thank Julian Williams representing the estate of Katherine Shonfield, and Frank O'Sullivan collaborator and photographer in the project *Matter out of Place*.

In 2011 on a visit from the 'Antipathies' to London, that crumbling centre of Empire, and travelling with the full family cohort, we happened upon an exhibition at the Wellcome Collection, in the same neighbourhood as the Bartlett School of Architecture. With two sons, considerably smaller at that time, we ventured

from room to room delving deeper into an exhibition called *Dirt: The Filthy Reality of Everyday Life.* What pleasures! So, this small book is further dedicated to a stinky-arse dog, two rather smelly boys and a publisher life-partner with a whip, demanding the dirt, and yes, this dirt is for you my love. This book has been written in the interstices of everyday life, some-how, between dishes and bedtime kisses.

Bibliography

Agrest, Diane, Patricia Conway and Leslie Kanes Weisman, eds. *The Sex of Architecture*. New York: Harry N. Abrams, 1996.

Barker, Lorina L., Adele Nye and Jennifer Charteris. "Voice, Representation and Dirty Theory." *Postcolonial Directions in Education* 6, no. 1 (2017): 54–81.

Bateson, Gregory. *Steps to an Ecology of Mind*. Chicago: University of Chicago Press, 2000.

Benjamin, Walter. "Theses on the Philosophy of History." In *Illuminations*, 245-255. London: Fontana Press, 1992.

Bennett, Jane. *Vibrant Matter: A Political Ecology of Things*. Durham, NC: Duke University Press, 2010.

Bennett, Jill. "Living in the Anthropocene." In *The Book of Books, Catalog 1/3, dOCUMENTA 13*, 344–47. Ostfildern, Germany: Hatje Cantz Verlag, 2012.

Bliss, Laura. "The Artist who Made Sanitation Workers Worthy of a Museum." *CityLab*, November 29, 2016. https://www.citylab.com/life/2016/11/the-artist-who-made-sanitation-workers-worthy-of-a-museum/508862/.

Bloomer, Jennifer. "Abodes of Flesh: Tabbles of Bower." *Assemblage* 17 (1992): 6–29.

Bloomer, Jennifer. *Architecture and the Text: The (S)crypts of Joyce and Piranesi*. New Haven and London: Yale University Press, 1993.

Burns, Karen. "Ex libris: Archaeologies of Feminism, Architecture and Deconstruction." *Architectural Theory Review* 15, no. 3 (2010): 242–265.

Burns, Karen. "Becomings: Architecture, Feminism, Deleuze – Before and After the Fold." In *Deleuze and Architecture*, edited by Hélène Frichot and Stephen Loo, 15–39. Edinburgh: Edinburgh University Press, 2012.

Burroughs, Brady. *Architectural Flirtations: A Love Storey*. PhD diss., KTH Stockholm. Stockholm: Architecture and Design Centre, 2016.

Butler, Judith. *Gender Trouble: Feminism and the Subversion of Identity*. London: Routledge, 1990.

Butler, Judith. "Rethinking Vulnerability and Resistance." *BIBACC*, June, 2014. http://bibacc.org/wp-content/uploads/2016/07/Rethinking-Vulnerability-and-Resistance-Judith-Butler.pdf.

Butler, Judith. "Vulnerability and Resistance." In *Vulnerability in Resistance*, edited by Judith Butler, Zeynep Gambetti and Leticia Sabsay, 12–27. Durham, NC: Duke University Press, 2016.

Campkin, Ben. "Ornament from Grime: David Adjaye's Dirty House, the architectural 'aesthetic of recycling' and the Gritty Brits." *The Journal of Architecture* 12, no. 4 (2007): 367–392.

Campkin, Ben. "Degradation and Regeneration: Theories of Dirt and the Contemporary City." In *Dirt: New Geographies of Cleanliness and Contamination*, edited by Ben Campkin and Rosie Cox, 68–79. London: I. B. Tauris, 2012.

Campkin, Ben and Rosie Cox. "Introduction: Materialities and Metaphors of Dirt and Cleanliness." In *Dirt: New Geographies of Cleanliness and Contamination*, edited by Ben Campkin and Rosie Cox, 1–10. London: I.B. Taurus, 2007.

Cheatle, Emma. *Part-Architecture: The Maison de Verre, Duchamp, Domesticity and Desire in 1930s Paris*. Abingdon, Oxon: Routledge, 2017.

Coleman, Debra. "Introduction." In *Architecture and Feminism*, edited by Elizabeth Danze and Debra Coleman, ix-xv. New York: Princeton Architectural Press, 1996.

Childers, Sara, Jeong-eun Rhee and Stephanie Daza. "Promiscuous (use of) Feminist Methodologies: The Dirty Theory and Messy Practice of Educational Research Beyond Gender." *International Journal of Qualitative Studies in Education* 25, no. 5 (2013): 507–503.

Connell, Raewyn. *Southern Theory. The Global Dynamics of Knowledge in Social Science*. Crows Nest, Australia: Allen & Unwin, 2007.

Cousins, Mark. "The Ugly." *AA Files* 28 (1994): 61–64.

Cousins, Mark. "The Ugly." *AA Files*, 29 (1995): 3–6.

Cox, Rosie, Rose George, R. H. Horne, Robin Nagle, Elizabeth Pisani, Brian Ralph, and Virginia Smith. *Dirt: The Filthy Reality of Everyday Life*. London: Profile Books, 2011.

Danze, Elizabeth and Debra Coleman, eds. *Architecture and Feminism*. New York: Princeton Architectural Press, 1996.

Deleuze, Gilles. *The Logic of Sense*. New York: Columbia University Press, 1990.

Deleuze, Gilles. *Difference and Repetition*. New York: Cornell University Press, 1994.

Deleuze, Gilles. "Letter to a Harsh Critic." In *Negotiations*, 3–12. New York: Columbia University Press, 1995.

Deleuze, Gilles and Félix Guattari. *A Thousand Plateaus: Capitalism and Schizophrenia*, Minneapolis: University of Minnesota Press, 1987.

Deleuze, Gilles and Félix Guattari. *What is Philosophy?* New York: Columbia University Press, 1994.

Documenta. "Documenta (13): 9 June – 16 September 2012." Accessed July19, 2019. (https://www.documenta.de/en/retrospective/documenta_13).

Douglas, Mary. *Purity and Danger: An Analysis of Concepts of Pollution and Taboo*. London: Routledge, 1966.

Fraser, Nancy. "Contradictions of Capital and Care." *New Left Review* 100, (July/August, 2016): 99–117.

Federici, Silvia. *Wages Against Housework*. Bristol: Falling Wall Press, 1975.

Federici, Silvia. *Revolution at Point Zero: Housework, Reproduction and Feminist* Struggle. New York: PM Press & Common Notions, 2012.

Frichot, Hélène. *Creative Ecologies: Theorizing the Practice of Architecture*. London: Bloomsbury, 2018.

Frichot, Hélène, Gabrielsson, Catharina, Runting, Helen. Eds. 2017. *Architecture and Feminisms; Ecologies, Economies, Technologies*. Abingdon, Oxon: Routledge, 2017.

Frichot, Hélène and Helen Runting. "The Queue." *Overgrowth. eflux architecture* (2019). Accessed September 13, 2019. https://www.e-flux.com/architecture/overgrowth/282654/the-queue/.

Gatens, Moira. *Feminism and Philosophy: Perspectives on Difference and Equality*. Bloomington and Indianapolis: Indiana University Press, 1991.

Genosko, Gary. "Megamachines: From Mumford to Guattari." *Explorations in Media Ecology* 14, no 1-2 (2015): 7–20.

Giedion, Sigfried. *Mechanization Takes Command: A Contribution to Anonymous History*. Minneapolis and London: University of Minnesota Press, 2013.

Gibson-Graham, J. K. *A Postcapitalist Politics*. Minneapolis: University of Minnesota Press, 2006.

Gissen, David. *Subnature: Architecture's Other Environments*. New York: Princeton Architectural Press, 2009.

Grusin, Richard, ed. *The Nonhuman Turn*. Minneapolis: University of Minnesota Press, 2015.

Haraway, Donna. 1988. "Situated Knowledges: The Science Question in Feminism and the Privilege of Partial Perspective." *Feminist Studies*, 14 (3): 575–99.

Haraway, Donna. "A Cyborg Manifesto: Science, Technology and Socialist-Feminism in the Late Twentieth Century." In *Simians, Cyborgs, and Women: The Reinvention of Nature*, 149-182. London: Free Association Books, 1991.

Haraway, Donna. *When Species Meet*. Minneapolis, MN: University of Minnesota Press, 2007.

Haraway, Donna. "SF Speculative Fabulation and String Figures." In *The Book of Books*, Catalog 1/3, dOCUMENTA 13, 253-255. Ostfildern, Germany: Hatje Cantz Verlag, 2012.

Haraway, Donna. *Staying with the Trouble: Making Kin in the Chthulucene*. Durham and London: Duke University Press, 2016.

Harcourt, Wendy, Sacha Knox and Tara Tabassi. "Worldwise, Otherwise Stories for our Endtimes: Conversations on Queer Ecologies." In *Practicing Feminist Political Ecologies: Moving Beyond the 'Green Economy'*, edited by Wendy Harcourt and Ingrid Nelson, 286-308. London: Zed Books, 2015.

Brown, James Benedict, Harriet Harriss, Ruth Morrow and James Soane, eds. A Gendered Profession, The Question of Representation in Space Making. London: RIBA Publishing, 2016.

Holmstedt, Janna. "Works." Accessed September 13, 2019. http://jannaholmstedt.com/works.html.

Horne, R. H. and Nagle, Robin. "The Love a Landfill: Dirt and the Environment." In *Dirt: The Filthy Reality of Everyday Life* edited by Rosie Cox, Rose George, R. H. Horne, Robin Nagle, Elizabeth Pisani, Elizabeth Ralph, Virginia Smith. London: Profile Books, 2011.

Hughes, Francesca, ed. *The Architect Reconstructing Her Practice*. Cambridge, Massachusetts: The MIT Press, 1996.

Ingraham, Catherine. *Architecture and the Burdens of Linearity*. New Haven and London: Yale University Press, 1998.

Kant, Immanuel. *Critique of Pure Reason*. New York: Everyman's Library, 1979.

Kuokkanen, Rauna Johana. "What is hospitality in the academy? Epistemic ignorance and the (im)possible gift". *The Review of Education, Pedagogy, and Cultural Studies* 30, no.1 (2008): 60–82.

Kuokkanen, Rauna Johana. *Toward the Hospitality of the Academy: The (Im)possible gift of Indigenous Epistemes*, PhD Thesis, The University of British Columbia, 2004.

Latour, Bruno. *We Have Never Been Modern*. Cambridge MA: Harvard University Press, 1993.

Latour, Bruno. "Why Has Critique Run out of Steam? From Matters of Fact to Matters of Concern." *Critical Inquiry* (Winter, 2004): 225–248.

Latour, Bruno. "From Realpolitik to Dingpolitik, or How to Make Things Public." In *Making Things Public: Atmospheres of Democracy*, edited by Bruno Latour and Peter Weibel, 14–36. Cambridge, MA.: MIT Press, 2005.

Le Doeuff, Michèle. *Hipparchia's Choice: An Essay Concerning Women, Philosophy, Etc*. New York: Columbia University Press, 2007.

Le Guin, Ursula. *Lavinia*. Boston: Mariner Books, 2008.

Le Guin, Ursula. "Paradises Lost." In *The Lost and the Found: The Collected Novelas of Ursula K. Le Guin*, 689–802. New York: Sage Press, 2016.

Lewandowska, Marysia and Laurel Ptak, eds. *Undoing Property?* Berlin: Sternberg Press, 2013.

Lispector, Clarice. *The Passion according to G.H.* New York: New Directions Books, 2012.

Lloyd Thomas, Katie. "Lines in Practice: Thinking Architectural Representation Through Feminist Critiques of Geometry." *Geography Research Forum* 21 (2001): 57–76.

Liss, Andrea. *Feminist Art and the Maternal*. Minneapolis: University of Minnesota Press, 2009.

Martin, Reinhold. *Utopia's Ghost: Architecture and Postmodernism, Again*. Minneapolis, MN: University of Minnesota Press, 2010.

Massey, Doreen. *Space, Place, and Gender*. Cambridge: Polity Press, 1994.

Mazzei, Lisa, and Alecia Jackson. "Introduction: The limit of voice." In *Voice in Qualitative Inquiry: Challenging Conventional, Interpretive, and Critical Conceptions in Qualitative Research*, edited by Alecia Jackson and Lisa Mazzei, 1–15. London, UK: Routledge, 2009.

Mazzei, Lisa and Alecia Jackson. "Complicating Voice in a Refusal to 'let participants speak for themselves.'" *Qualitative Inquiry* 18 (2012): 745–751.

Miranda, Maria. n.d. "Waiting with Worms." Accessed September 14, 2019. https://vimeo.com/247735081.

Mostafavi, Mohsen and David Leatherbarrow. *On Weathering: The Life of Buildings in Time*. Cambridge, MA: MIT Press, 1993.

muf art/architecture. "muf." Accessed September 13, 2019. http://muf.co.uk.

Mumford, Lewis. *Technics and Civilization*. Chicago: University of Chicago Press, 2010.

Nancy, Jean-Luc. *The Sense of the World*. Minneapolis: University of Minnesota Press, 1997.

Parikka, Jussi. 2012. "New Materialism as Media Theory: Medianatures and Dirty Matter." *Communication and Critical/Cultural Studies* 9, no. 1 (March, 2012): 95–100.

Pentecost, Claire. "Notes from Underground." In *The Book of Books, Catalog 1/3, dOCUMENTA 13*, 384-388. Ostfildern, Germany: Hatje Cantz Verlag, 2012.

Pentecost, Claire. "soil-erg." Accessed July 19, 2019. http://www.publicamateur.org/?p=85.

Preston, Julieanna. *Performing Matter: Interior Surface and Feminist Actions*. Baunach: AADR Spurbuchverlag, 2014.

Puig de la Bellacasa, Maria. *Matters of Care: Speculative Ethics in More than Human Worlds*. Minneapolis: University of Minnesota Press, 2017.

Rawes, Peg. "Architectural Ecologies of Care." In *Relational Architectural Ecologies*, edited by Peg Rawes. London: Routledge, 2013.

Rendell, Jane. "Only Resist: A Feminist Approach to Critical Spatial Practice." *The Architectural Review* (February, 2018). https://www.architectural-review.com/essays/only-resist-a-feminist-approach-to-critical-spatial-practice/10028246.article.

Rendell, Jane. "Critical Spatial Practices: Setting Out a Feminist Approach to Some Modes and What Matters in Architecture." In *Feminist Practices: Interdisciplinary Approaches to Women in Architecture*, edited by Lori Brown, 17–56. London: Ashgate, 2011.

Ruedi, Katerina, Sarah Wigglesworth and Duncan McCorquodale, eds. *Desiring Practices: Architecture, Gender and the Interdisciplinary*. London: Black Dog Publishing, 1996.

Rossiter, Ned. "Translating the Indifference of Communication: Electronic Waste, Migrant Labour and the Informational Sovereignty of Logistics in China." *International Review of Information Ethics* 11 (October, 2009): 36-44. http://www.i-r-i-e.net/inhalt/011/011-full.pdf.

Runting, Helen. *Architectures of the Unbuilt Environment*. PhD thesis, KTH Stockholm. Stockholm: KTH Royal Institute of Technology, 2018.

Santos, "Book Review: Donna Haraway's Staying with the Trouble." *The Chart*, vol. 1, no. 4 (Summer, 2017). https://thechart.me/book-review-donna-haraway-staying-with-the-trouble/

Savransky, Mark. "Isabelle Stengers and the Dramatisation of Philosophy." *SubStance* 47, no. 1 (2018): 3–16.

Serres, Michel. *The Parasite*. Minneapolis: University of Minnesota Press, 2007.

Serres, Michel. *Malfeance: Appropriation Through Pollution?* Stanford California: Stanford University Press, 2011.

Schalk, Meike, Thérèse Kristiansson and Ramia Mazé, eds. *Feminist Futures of Spatial Practice: Materialisms, Activisms, Dialogues, Pedagogies, Projections*, Baunach Germany: AADR Spurbuchverlag, 2017.

Shiva, Vandana. "The Corporate Control of Life." In *The Book of Books, Catalog 1/3, dOCUMENTA 13*, 121–124. Ostfildern, Germany: Hatje Cantz Verlag, 2012.

Shonfield, Katherine. "Purity and Tolerance: How Building Construction Enacts Pollution Taboos." *AA Files* 28 (Autumn): 34–40.

Shonfield, Katherine and Frank O'Sullivan. "Dirt is Matter Out of Place." In *Architecture: The Subject is Matter*, edited by Jonathan Hill, 29-44. London: Routledge, 2001.

Sloterdijk, Peter. *Spheres vol. 1. Bubbles*. Los Angeles: Semiotext(e), 2011.

Subramanian, Meera. "Anthropocene Now: International Panel Votes to Recognize Earth's New Epoch." *Nature*, (21 May, 2019). https://www.nature.com/articles/d41586-019-01641-5.

Stengers, Isabelle. "Reclaiming Animism." *e-flux* 36 (2012). Accessed 2 February 2017. http://www.e-flux.com/journal/36/61245/reclaiming-animism/

Stengers, Isabelle. *In Catastrophic Times: The Coming Barbarism*. Ann Arbor, MI: Open Humanities Press and Meson Press, 2015.

Stengers, Isabelle and Vinciane Despret. *Women Who Make a Fuss: The Unfaithful Daughters of Virginia Woolf*. Minneapolis: University of Minnesota Press, 2014.

Tronto, Joan. *Who Cares? How to Reshape a Democratic Politics*. Ithaca, New York: Cornell University Press, 2015.

Tsing, Anna. *The Mushroom at the End of the World: On the Possibility of Life in Capitalist Ruins*. Princeton, NJ: Princeton University Press, 2015.

Ukeles, Mierle Laderman. "Manifesto for Maintenance Art". 1969. In *Art in Theory 1900–2000: An Anthology of Changing Ideas*, edited by Charles Harrison and Paul Wood, 917–919. Oxford: Blackwell, 2003.

Van Toorn, Roemer. "Dirty Regionalism." In *Tangible Traces*, edited by Linda Vlassenrood and Mirjam van der Linden, 151–162. Rotterdam: Nai Publishers, 2009.

Van Toorn, Roemer. "Dirty Detail." Post.Rotterdam, edited by Pedro Gadanho, 122–132. Rotterdam: Nai Publishers, 2001.

Vergès, Françoise. "Capitalocene, Waste, Race, and Gender" *eflux Journal* 100 (May 2019). Accessed 3 May 2019. https://www.e-flux.com/journal/100/269165/capitalocene-waste-race-and-gender/.

von Schantz, Miriam and Hélène Frichot. "On the Irrational Section Cut." In *After Effects: Theories and Methodologies in Architectural Research*, edited by Hélène Frichot with Gunnar Sandin, Bettina Schwalm, 252–271. New York and Barcelona: Actar, 2019.

THE PRACTICE OF THEORY AND THE THEORY OF PRACTICE

The Deutsche Nationalbibliothek lists this publication in the Deutsche Nationalbibliografie; detailed bibliographic information is available on the internet at http://dnb.d-nb.de

Dirty Theory: Troubling Architecture
Hélène Frichot

© Copyright 2019 by Author and Spurbuchverlag
ISBN: 978-3-88778-564-2
Publication © by Spurbuchverlag 1. print run 2019
Am Eichenhügel 4, 96148 Baunach, Germany
All rights reserved.

AADR – Art Architecture Design Research publishes research with an emphasis on the relationship between critical theory and creative practice.
AADR Curatorial Editor: Prof Dr Rochus Urban Hinkel, Stockholm
Production: pth-mediaberatung GmbH, Würzburg
Graphic Design: Moa Sundkvist, Stockholm